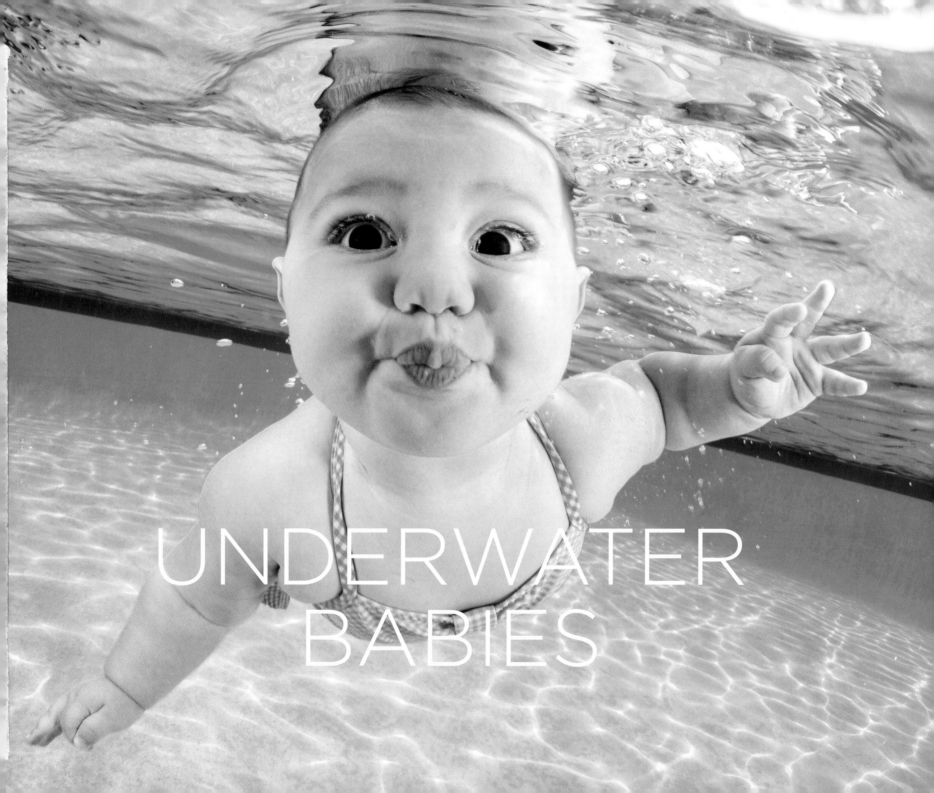

UNDERWATER
BABIES

Also by Seth Casteel

Underwater Puppies

Underwater Dogs

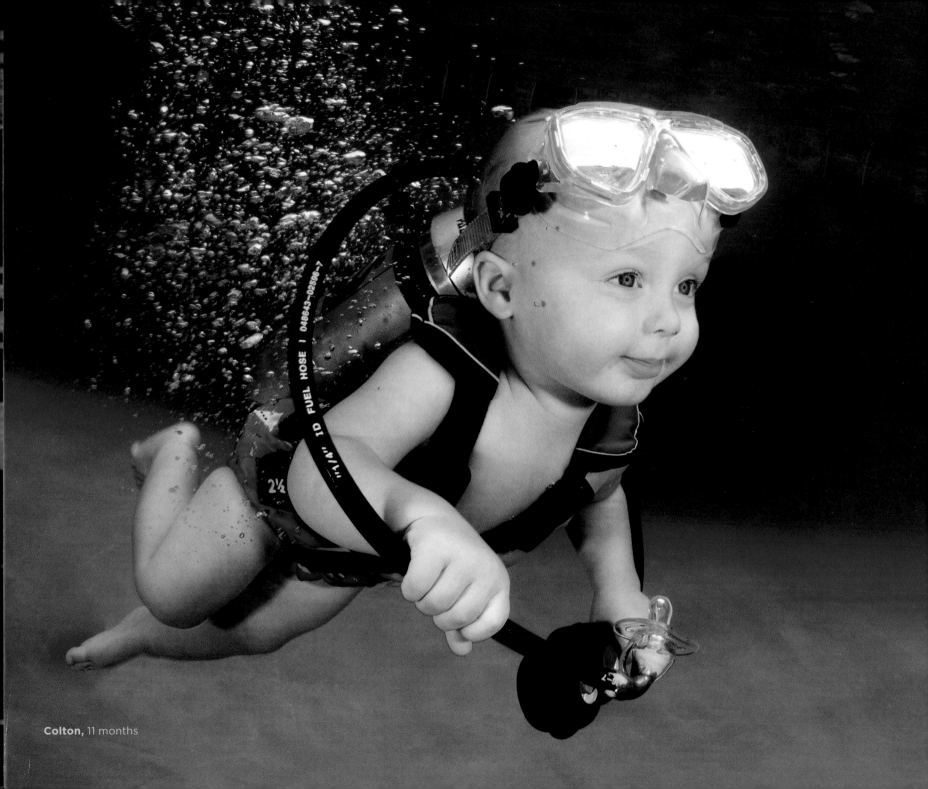

Colton, 11 months

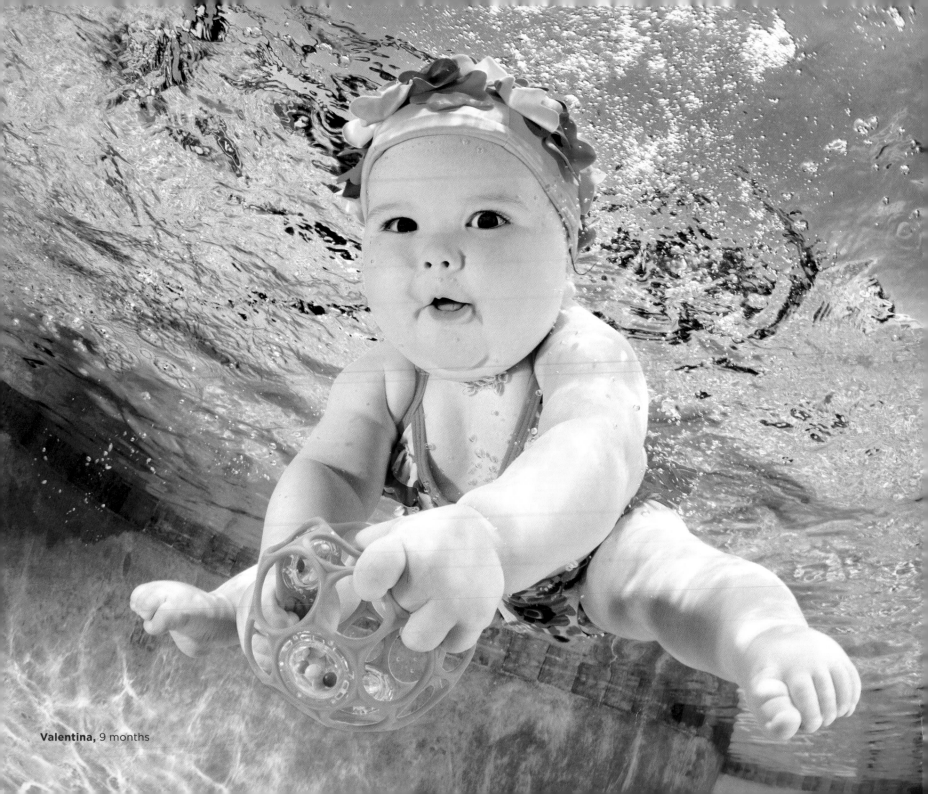

Valentina, 9 months

UNDERWATER BABIES

Seth Casteel

LITTLE, BROWN AND COMPANY
New York Boston London

Little, Brown and Company
Hachette Book Group
1290 Avenue of the Americas, New York, NY 10104
littlebrown.com

First Edition: April 2015

Little, Brown and Company is a division of Hachette Book
Group, Inc. The Little, Brown name and logo are trademarks
of Hachette Book Group, Inc.

The publisher is not responsible for websites (or their content)
that are not owned by the publisher.

The Hachette Speakers Bureau provides a wide range
of authors for speaking events. To find out more, go to
hachettespeakersbureau.com or call (866) 376-6591.

On-land photographs courtesy of family and friends of babies.

ISBN 978-0-316-25650-6
LCCN 2014959605

10 9 8 7 6 5 4 3 2 1

WOR

Design by Gary Tooth / Empire Design Studio

Printed in the United States of America

I dedicate this book to all of the babies, parents, and swim teachers
who participated in its creation! Thank you for helping to bring awareness
to such an important cause!

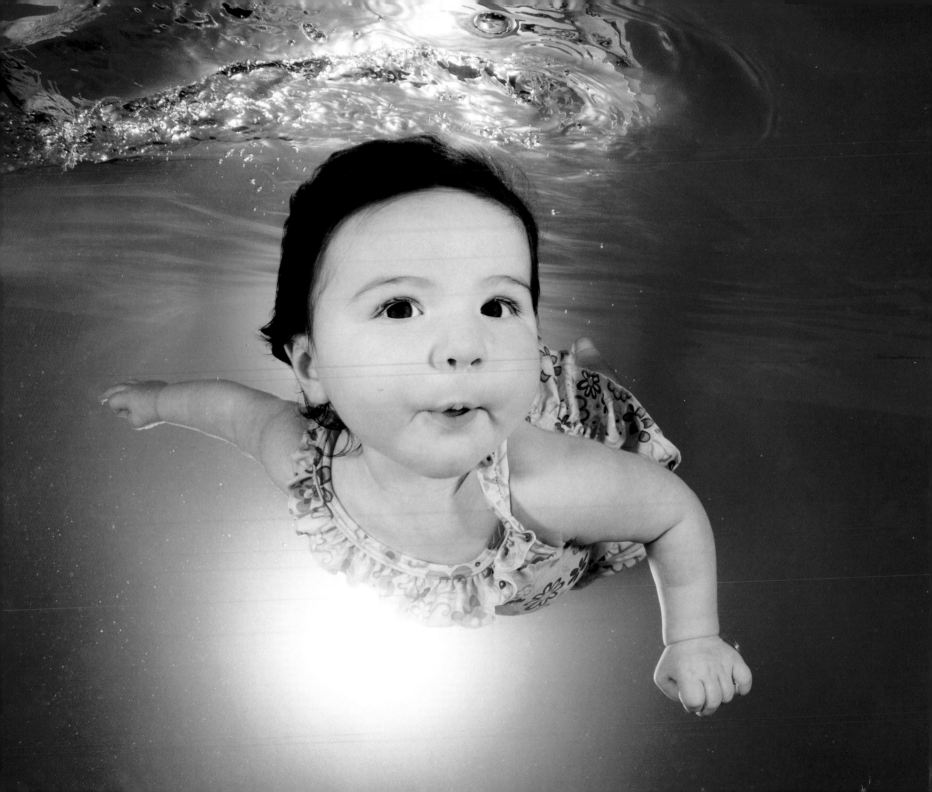

CONTENTS

Introduction

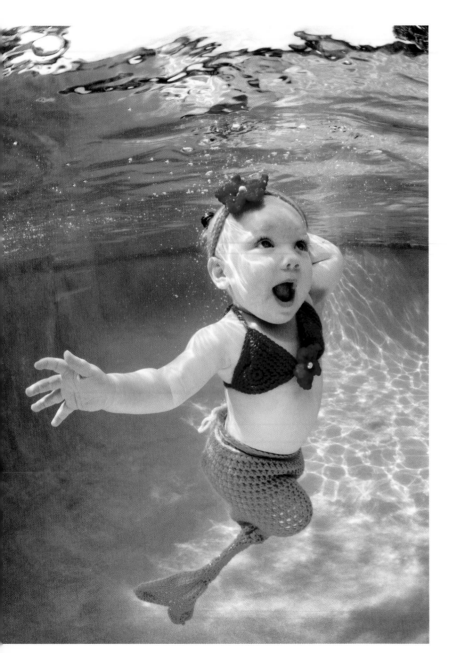

I'm thought of more as a "dogs guy," so even I find it a little surprising that I am the author of this book. But I've always loved being with babies, and on this project I was extremely inspired by every single baby I met and photographed. And in spending time with the many generous and loving parents I worked with on *Underwater Babies,* I immediately came to appreciate the responsibility and selflessness it requires to be a parent. The babies, their parents, and I had a fantastic experience!

So why did I make this book?
Everybody knows that humans evolved from mermaids, which helps us understand why we as a species can truly thrive in the water. It's also clear that as we continue to embrace the water more and more, we may see a transition back to living in a world under the sea. Okay—so I'm obviously just kidding here, but I'm glad you are taking the time to read my introduction.☺

The real story starts for me when a little dog jumped into the pool a few years ago and my life changed forever. My first book, *Underwater Dogs,* began as a passionate project to explore the connection dogs have with the water and the fascinating range of emotions they reveal during their adventures below the surface. Throughout the course of that project, I realized humans lacked understanding when it came to water safety for their pets. Thousands of dogs in the United States suffer tragedies in backyard swimming pools every single year. It's not because they can't swim—it's because they haven't been given the opportunity to practice and don't understand how to get out. People just don't think about it.

With my next book, *Underwater Puppies,* I taught more than 1,500 puppies about water safety. They learned about buoyancy, their physicality in the water, and the concept of a swimming pool versus a natural body of water. Using the photographs as a vehicle, I delivered the message of water safety for pets to hundreds of millions of people in hopes of raising awareness of the potential dangers of swimming pools.

While working on the puppies project, I learned of shocking statistics regarding water-related accidents with human children. Drowning is the number one cause of accidental death for those under age five in the United States. The hidden dangers of swimming pools continue to cause tragedies every single day, but these tragedies can be prevented. I saw photography as an opportunity to help.

I set out on a mission to create a joyful, whimsical series of images of babies swimming to generate awareness about water safety for children. To produce these photographs, I teamed up with infant swimming schools throughout the United States. Each photo shoot was an actual swim lesson, with each baby learning water safety and survival skills.

I strongly advise parents to consider all of the amazing benefits of infant swimming lessons and to choose a program that is right for them and their child. Participation in formal swimming lessons can reduce the risk of drowning by 88 percent for children under age five.

Keeping our babies safe, whether they are fur babies or human babies, is our top priority. They are our responsibility. We are their guardians. We are their voice. I urge anyone with a pet or a child to take all precautions to ensure their charges are safe around the water, and also to enjoy the magic that can happen when we partake in the water the right way.

Some people looking at these images will be surprised, even shocked, that they are genuine. I not only expect this but welcome it. Among the children that are most vulnerable to tragedy are those being protected by parents who either don't know that water danger exists or, worse, consider swimming a risky activity. But in *Underwater Babies,* you are seeing what can happen when a loving and supportive parent introduces a baby to water in a safe and instructive environment. Outside the camera's lens, parents and instructors were in the pool with each baby to help make his or her experience joyful and safe. You'll notice the babies' amazing expressions. All of the children in my book are between four months and seventeen months old and possess the natural bradycardic reflex that makes it possible for them to hold their breath underwater. The process was astonishing to see, each and every time, and I feel lucky to share these very real underwater moments with you.

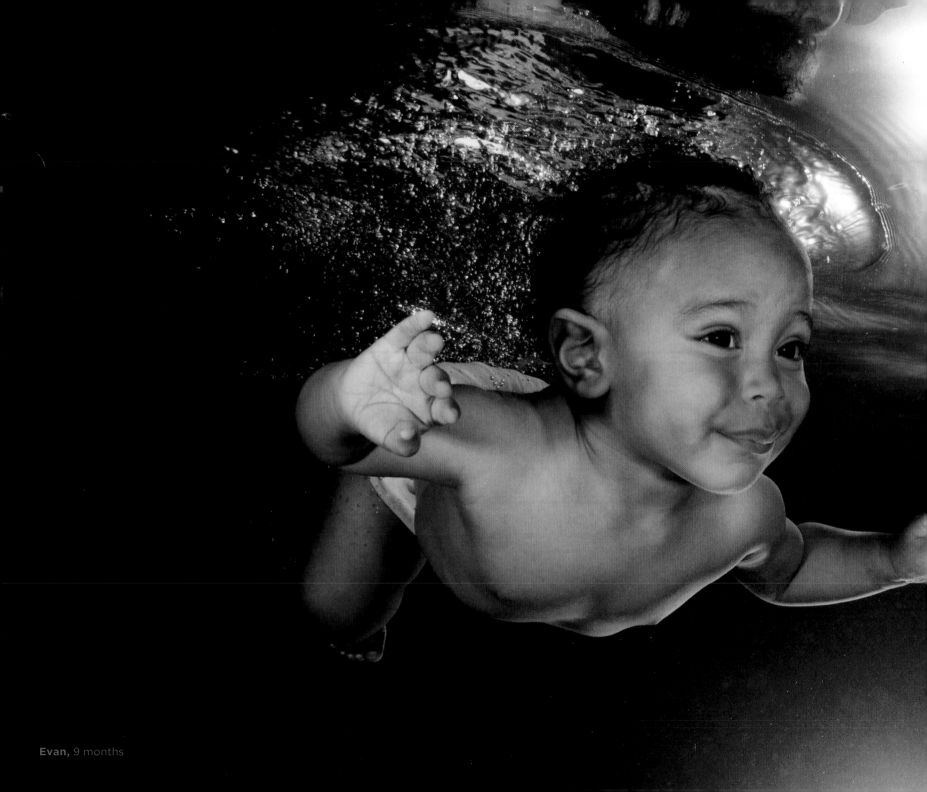

Evan, 9 months

UNDERWATER BABIES

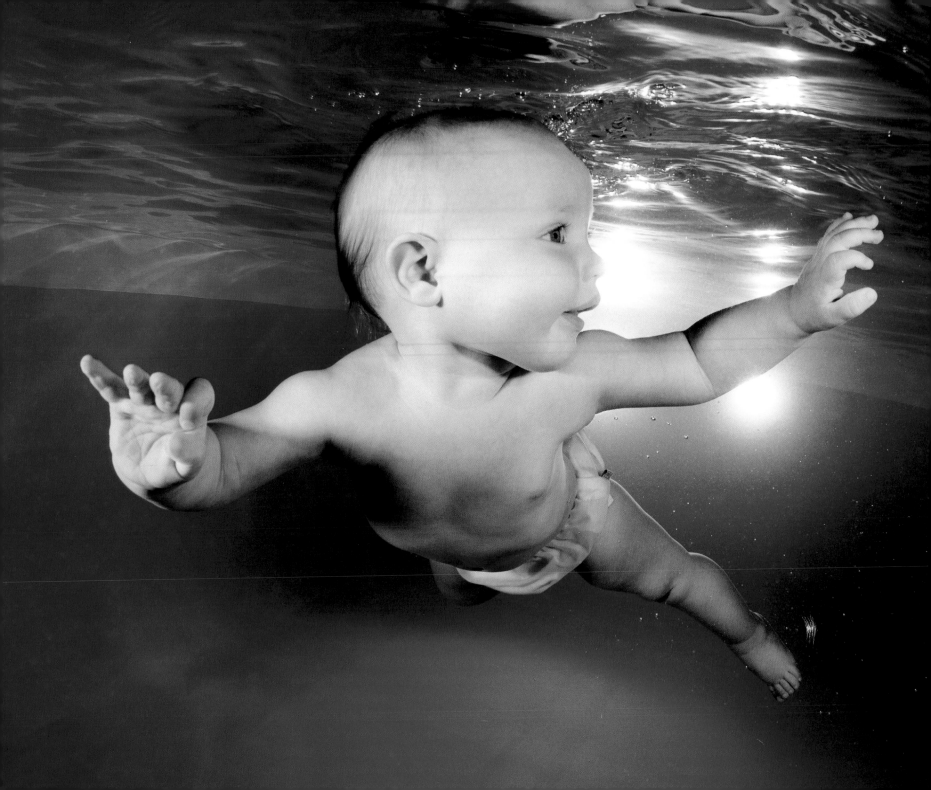

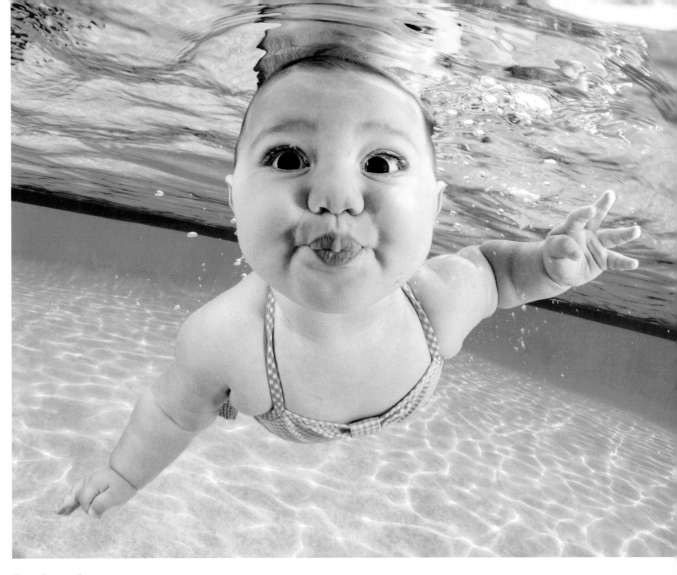

Zoe, 5 months

Basil Marie, 11 months

Aizlynn, 13 months

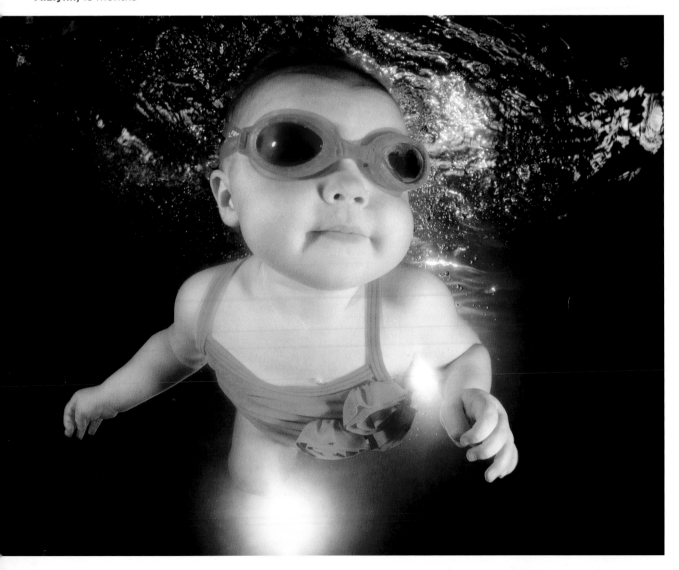

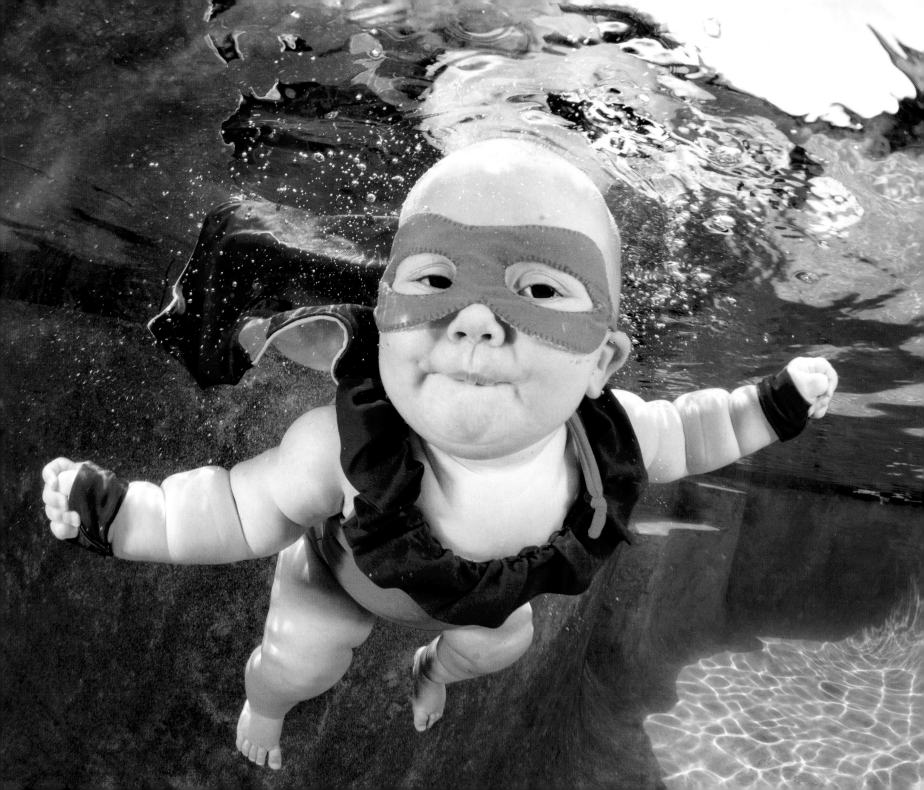

Kyndall, 12 months

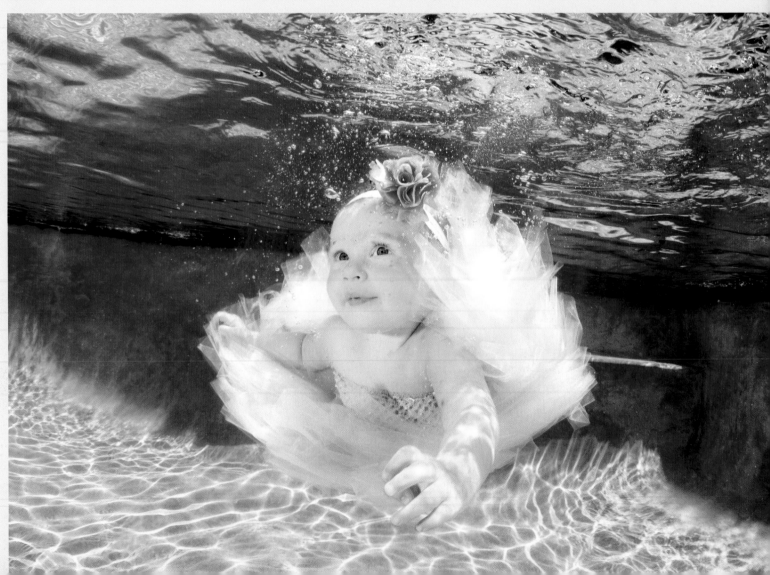

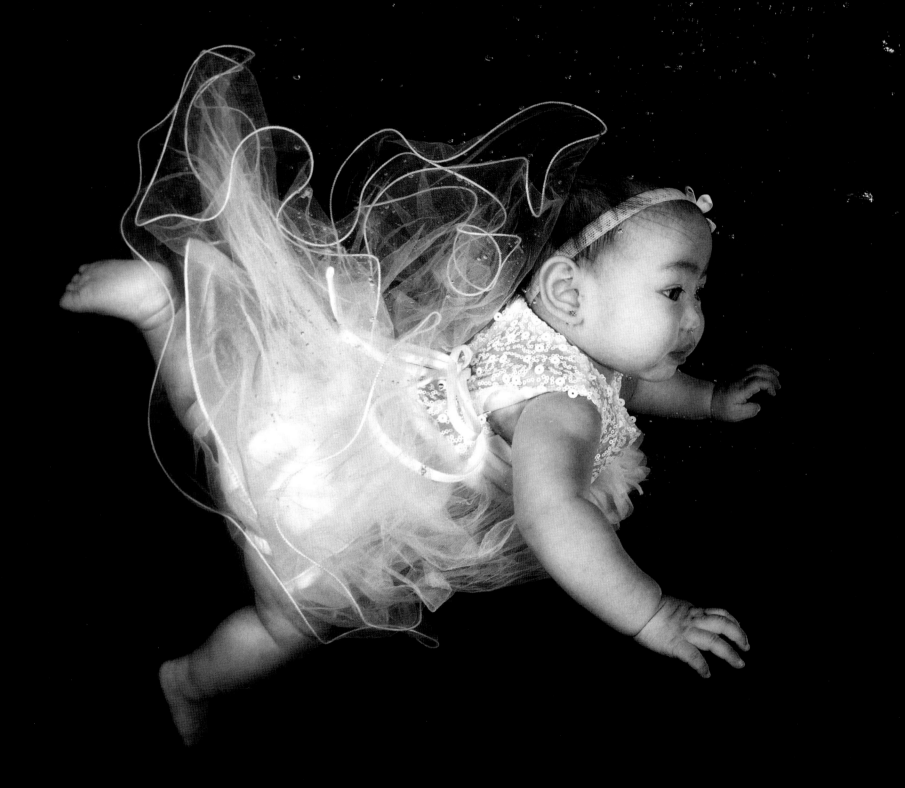

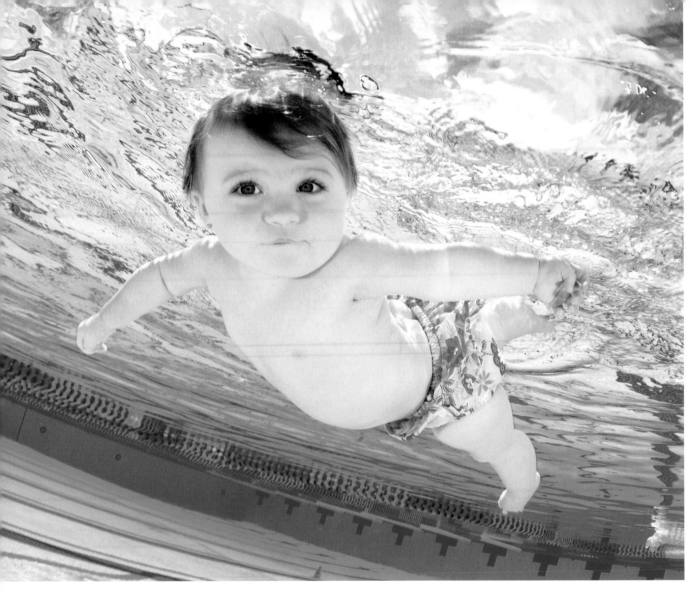

Landry, 7 months

Emerson, 7 months

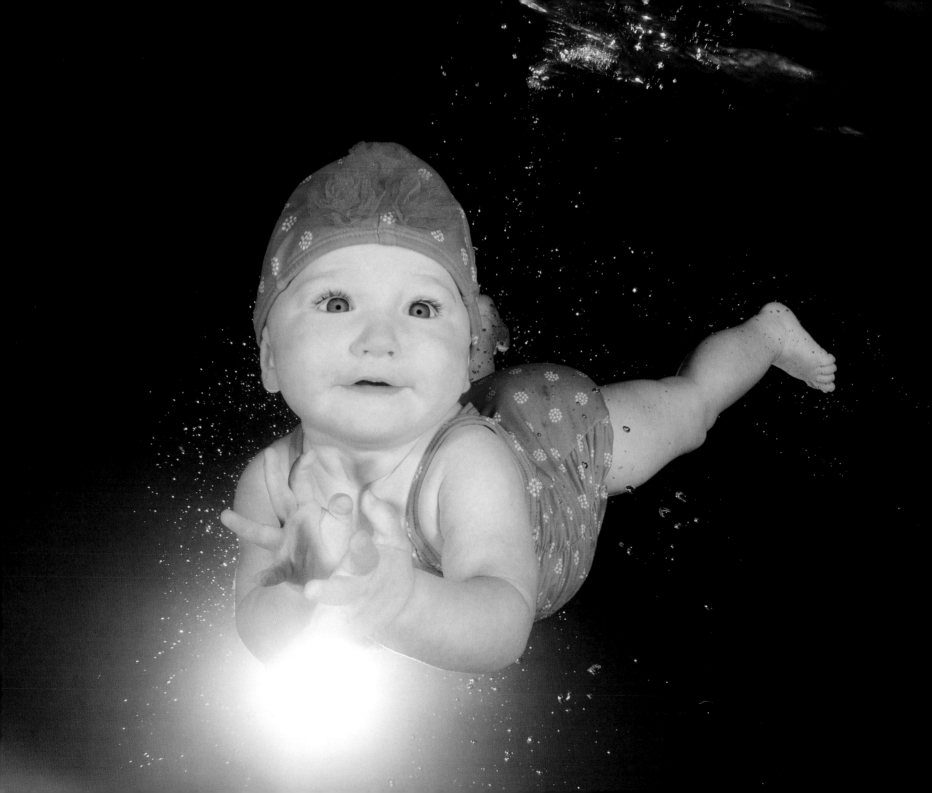

Mia, 9 months

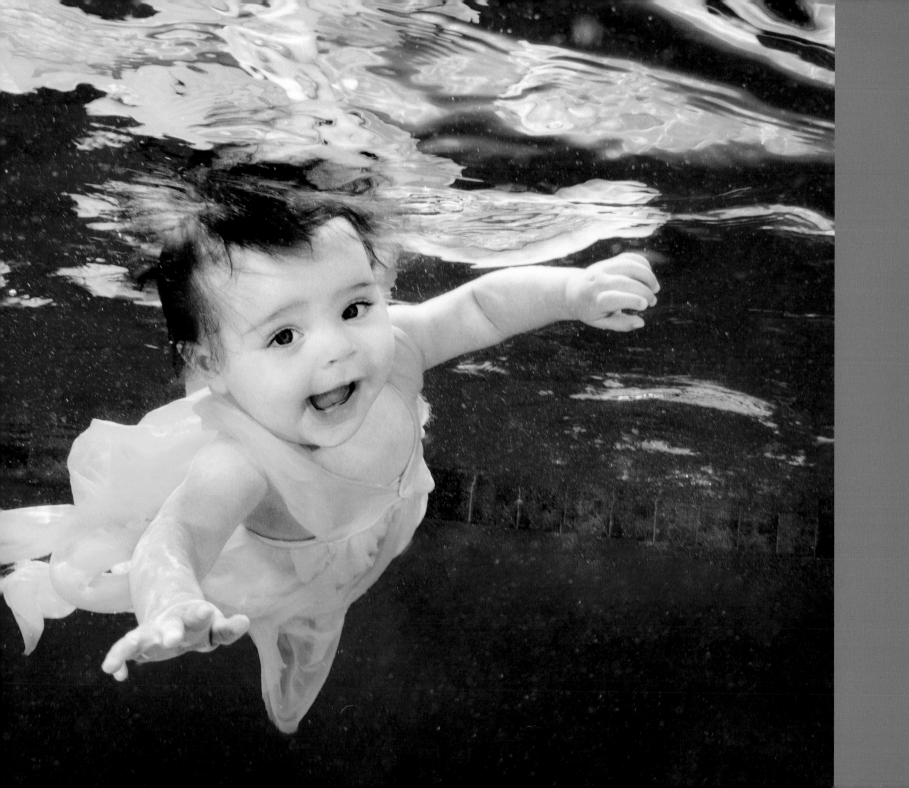

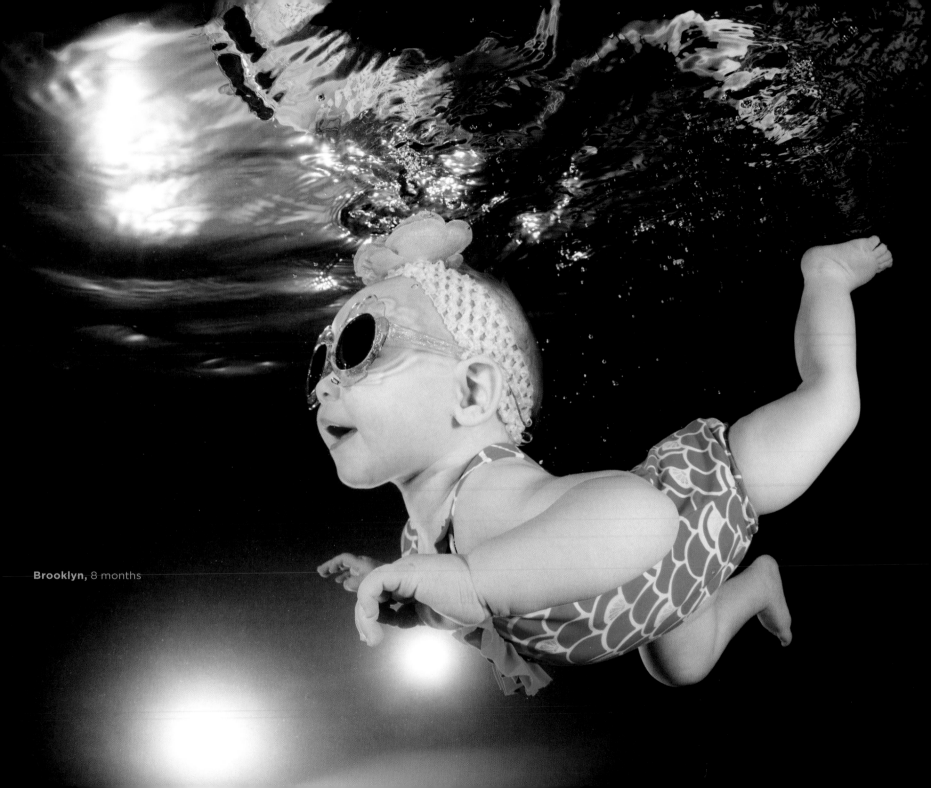

Brooklyn, 8 months

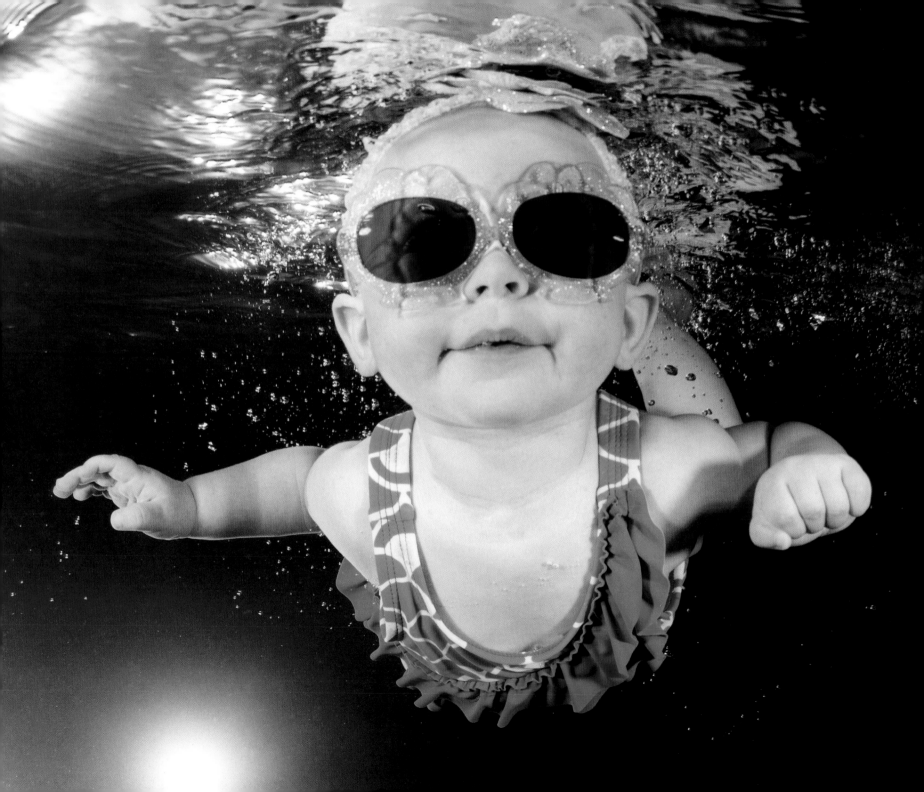

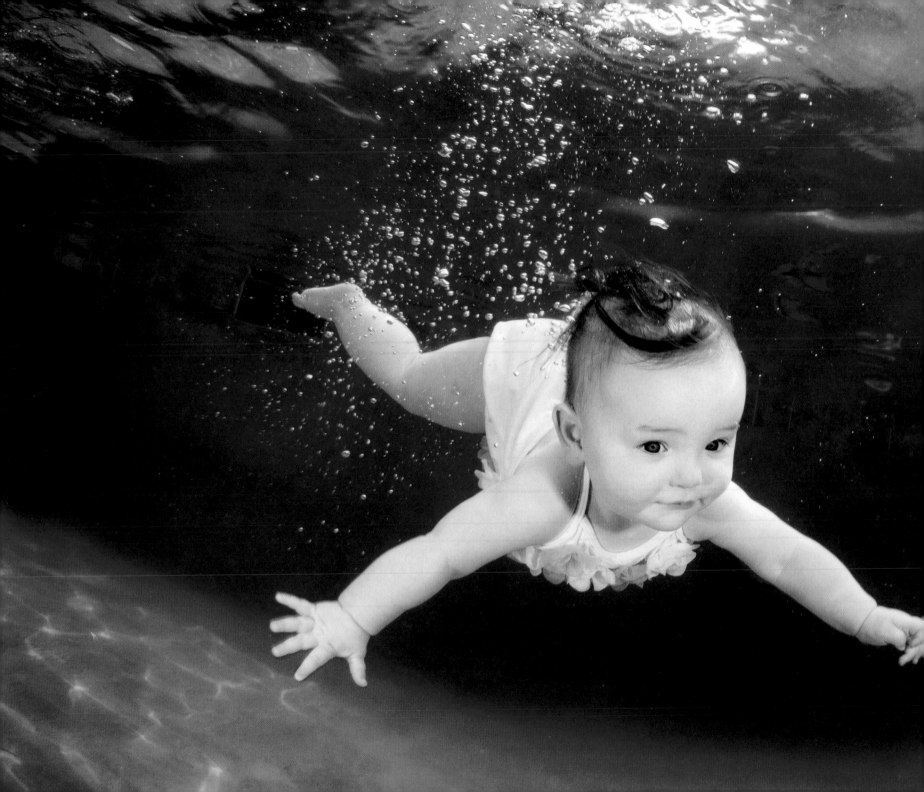

Emma, 8 months

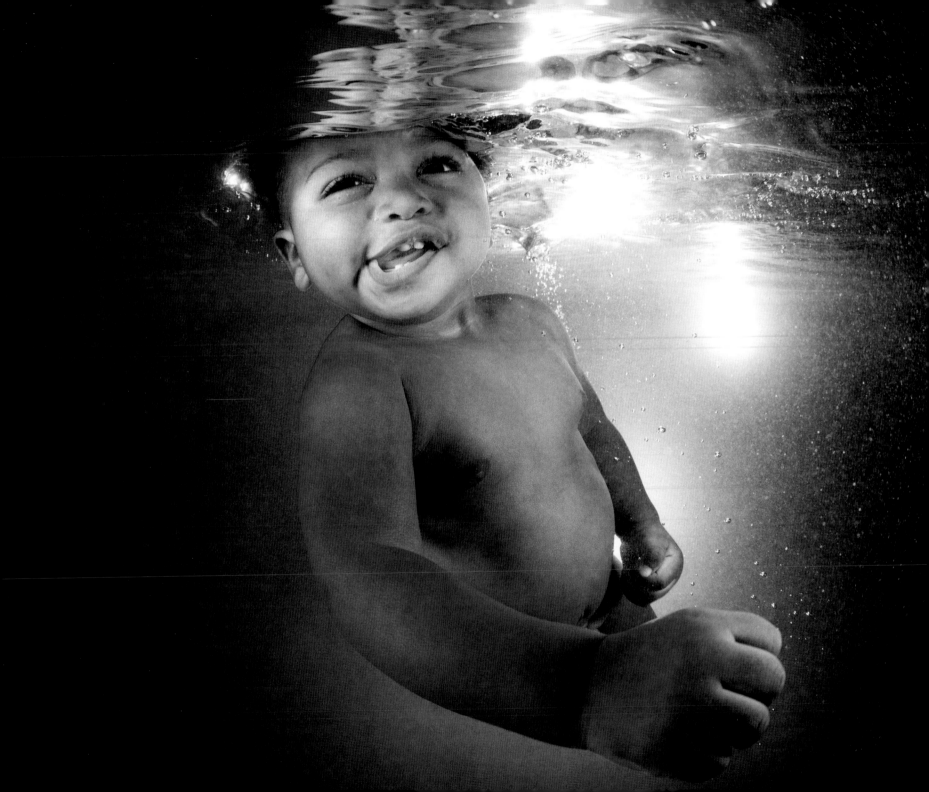

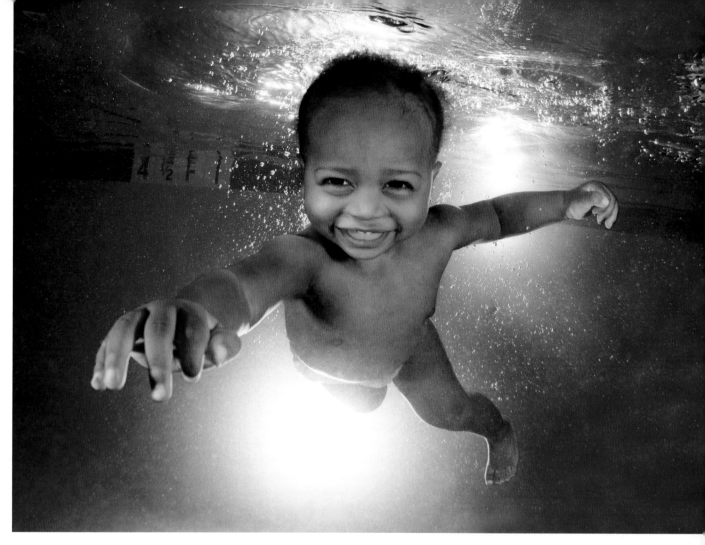

Warren M., 11 months

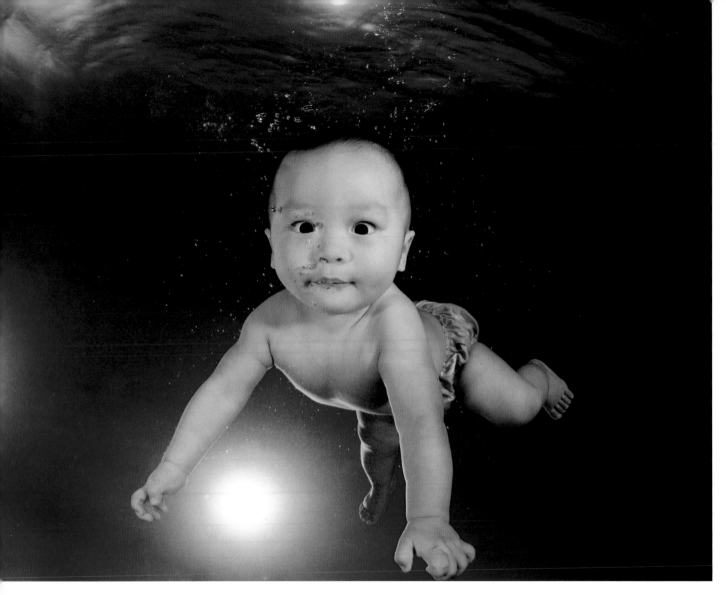

Charles, 8 months

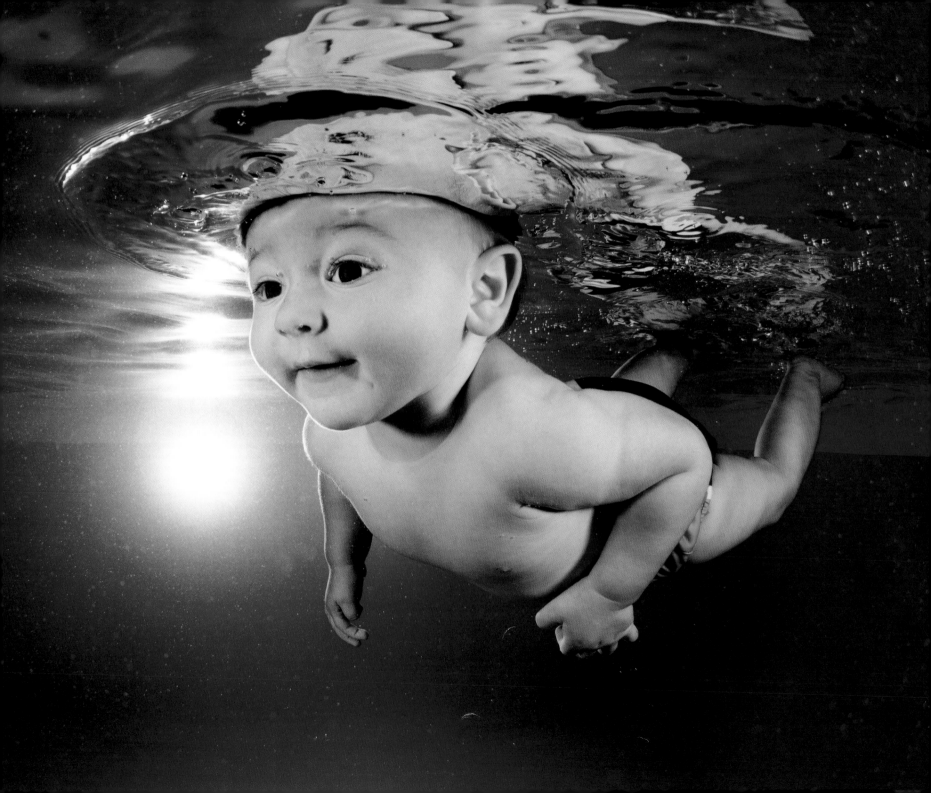

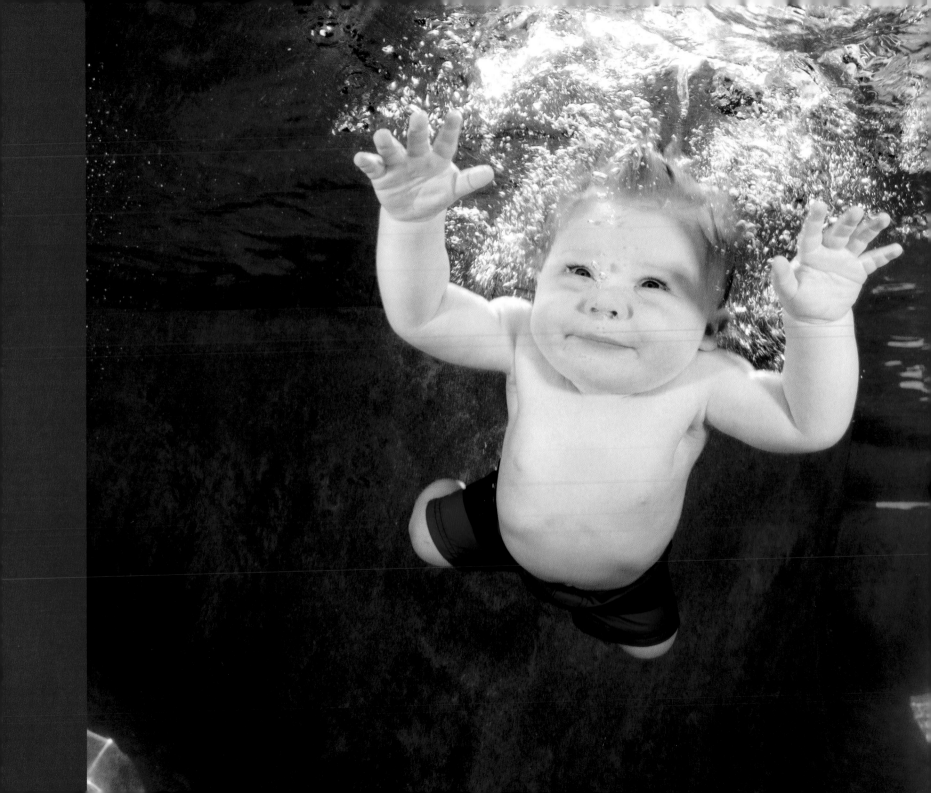

Miller, 10 months

Harper M., 14 months

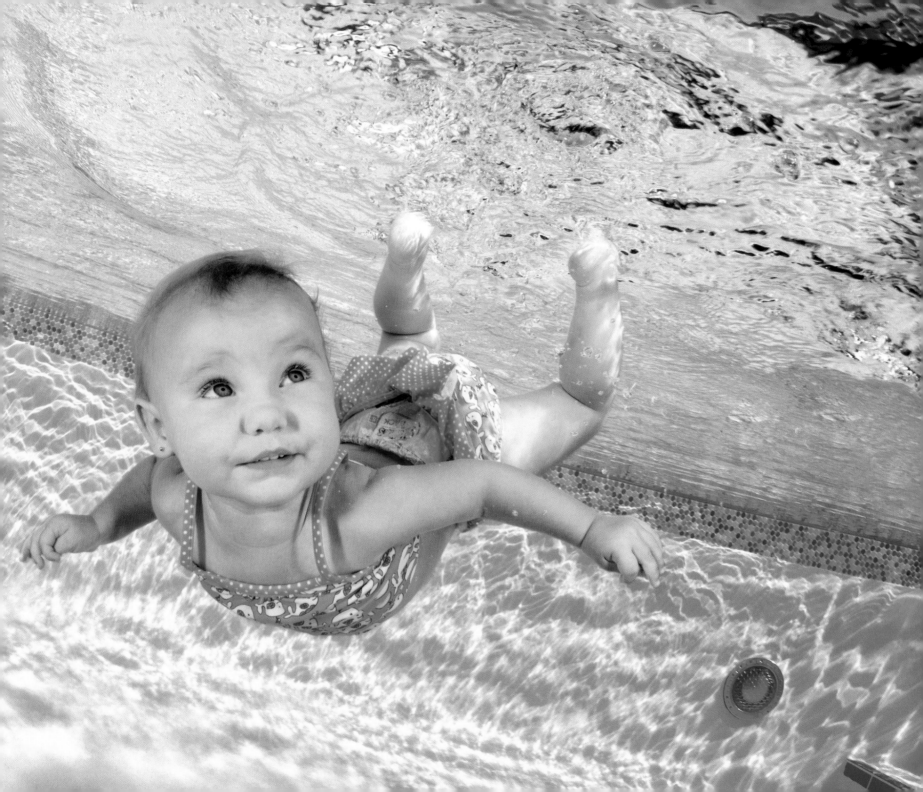

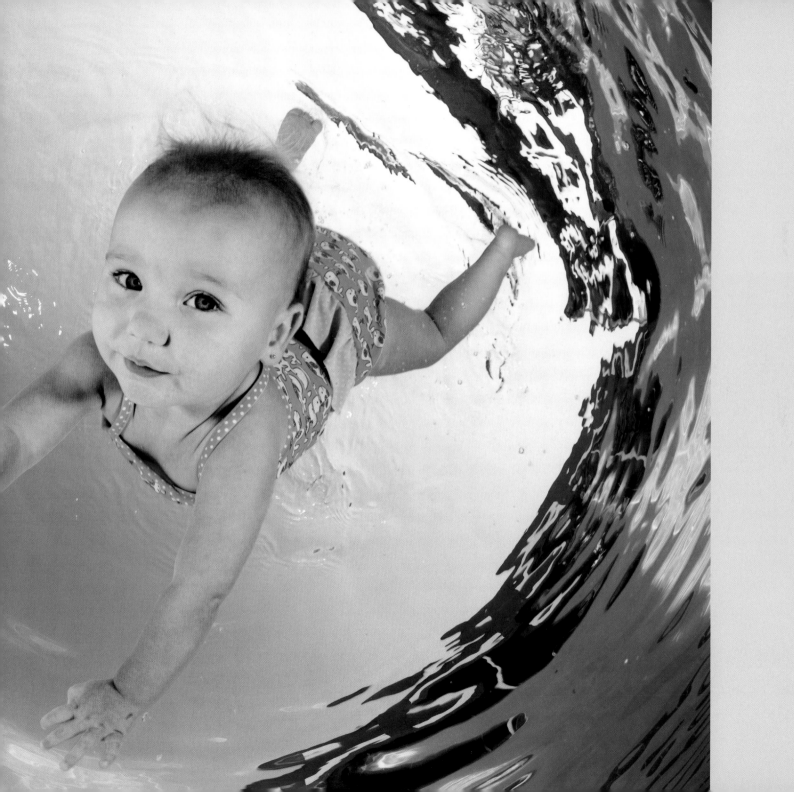

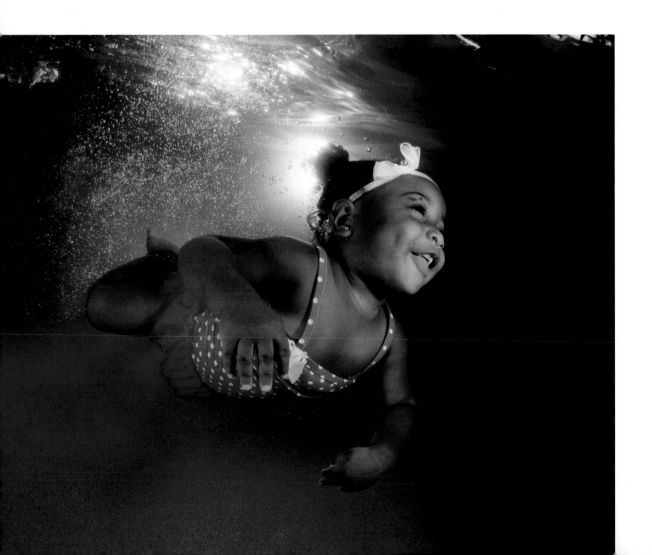

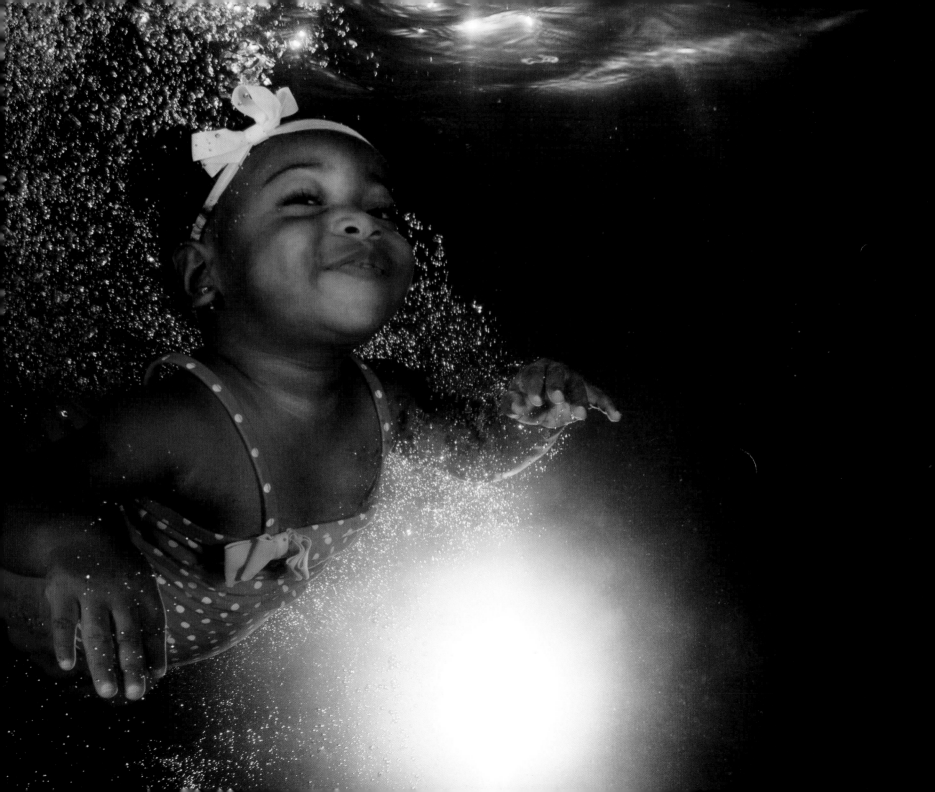

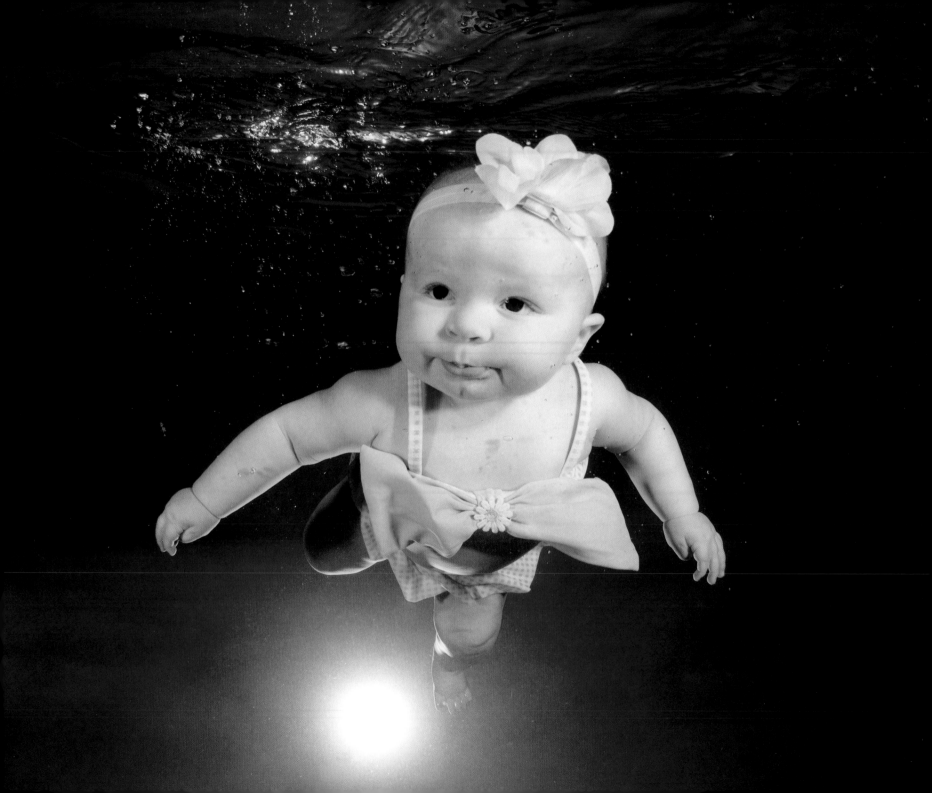

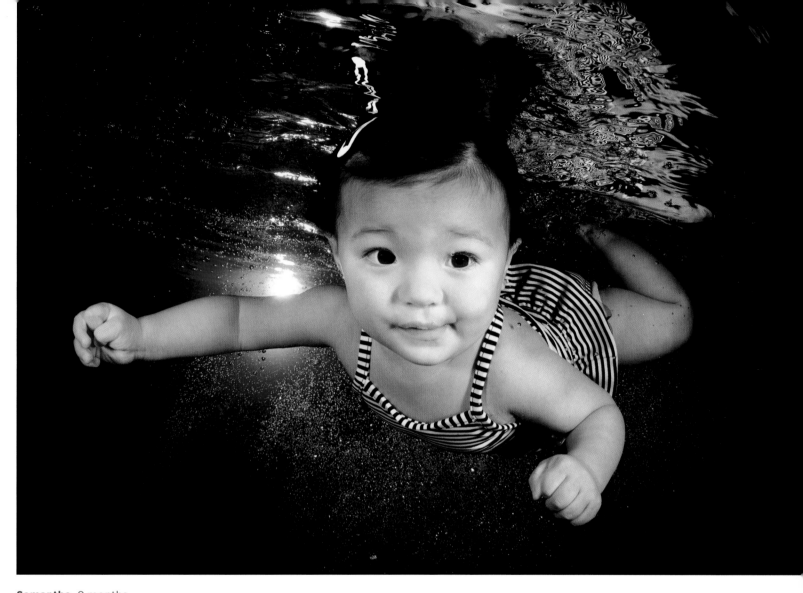

Samantha, 9 months

Prestyn, 5 months

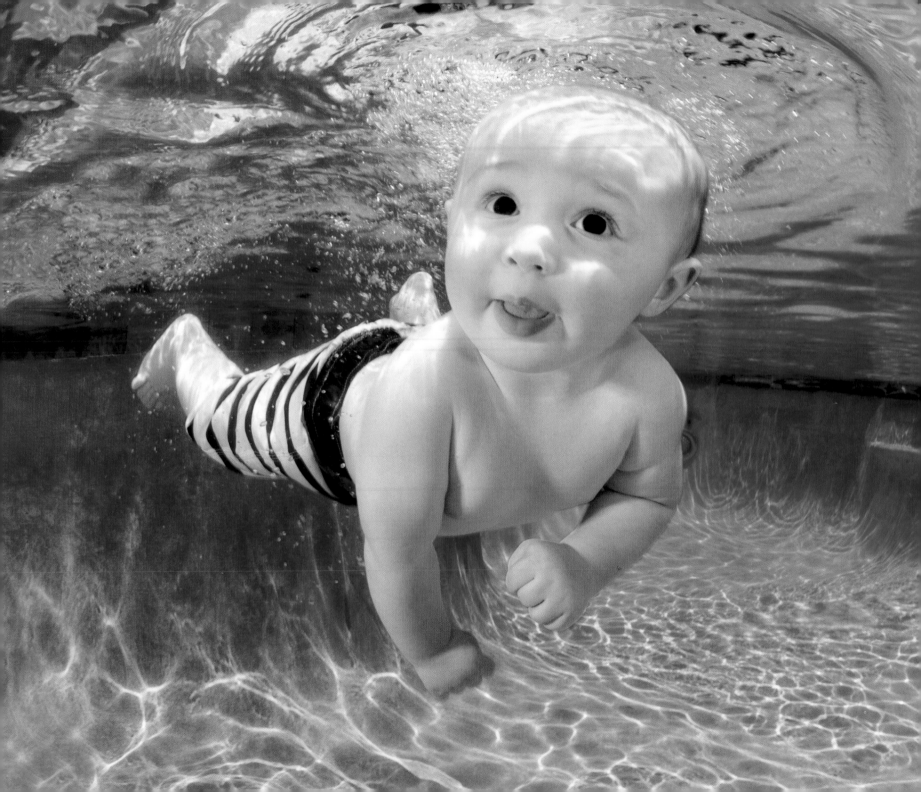

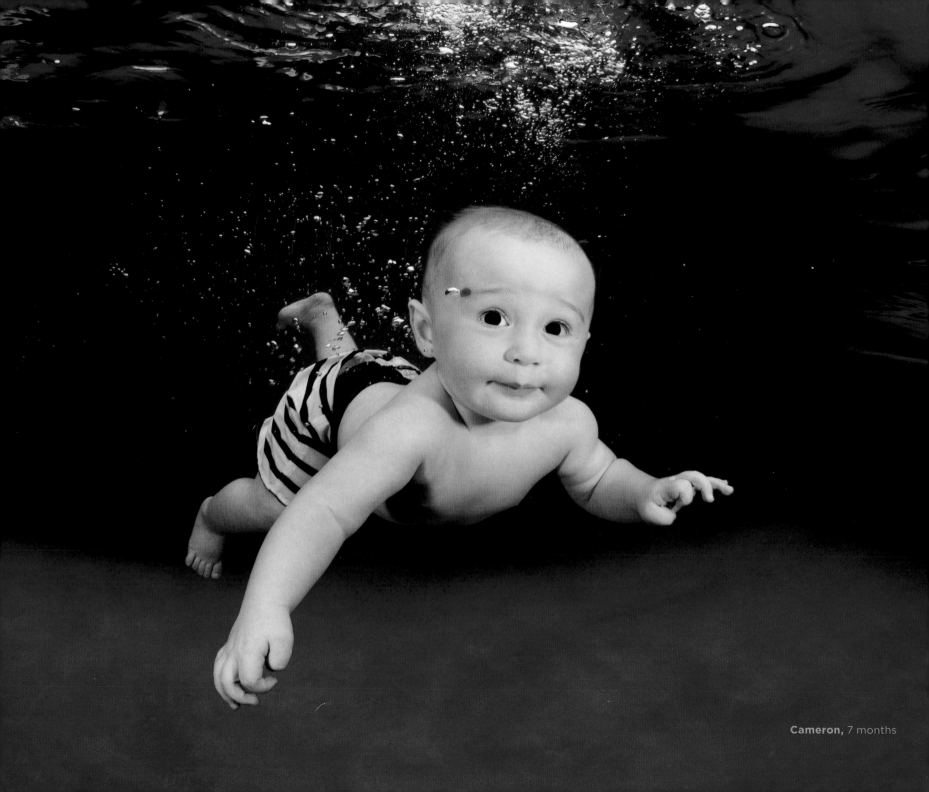

Cameron, 7 months

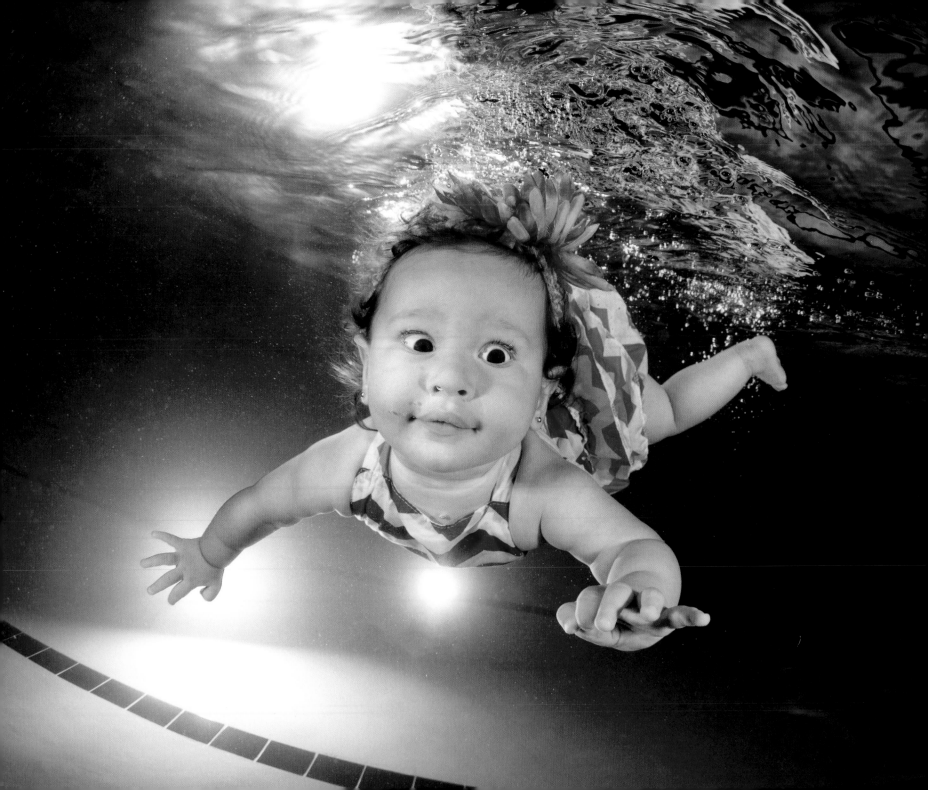

Gabriella, 11 months

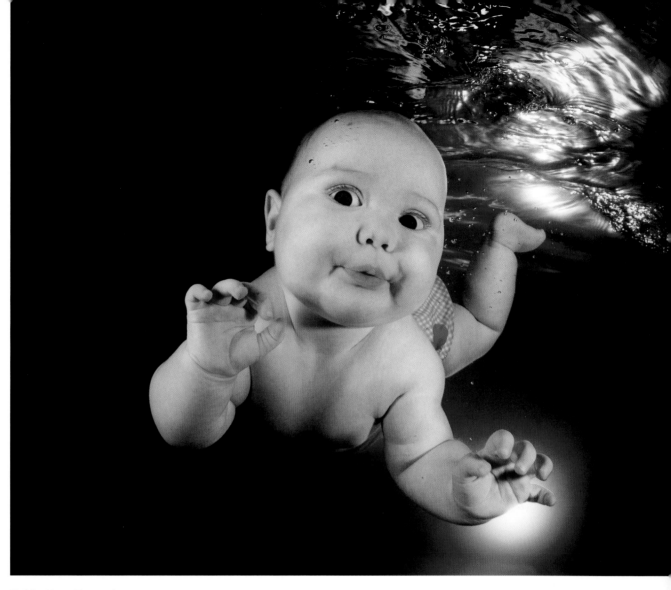

Zelda Mae, 7 months

Isabel B., 10 months

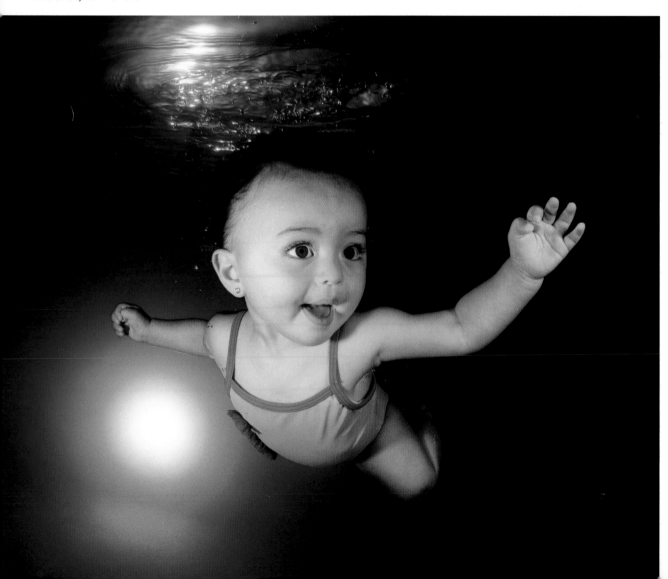

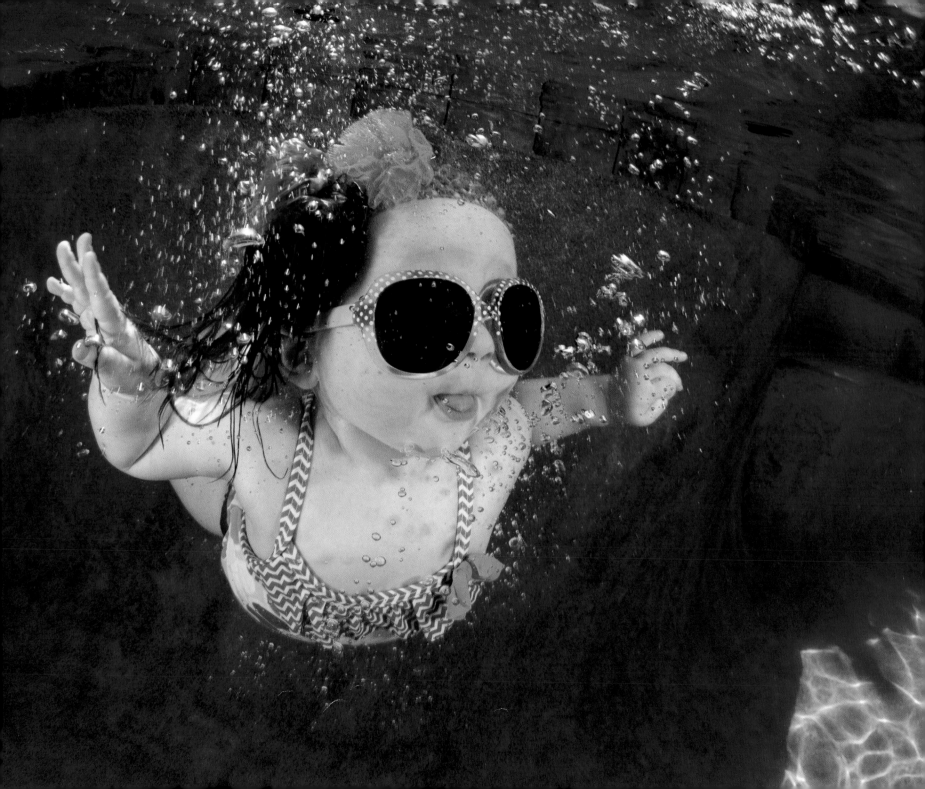

Noel, 11 months

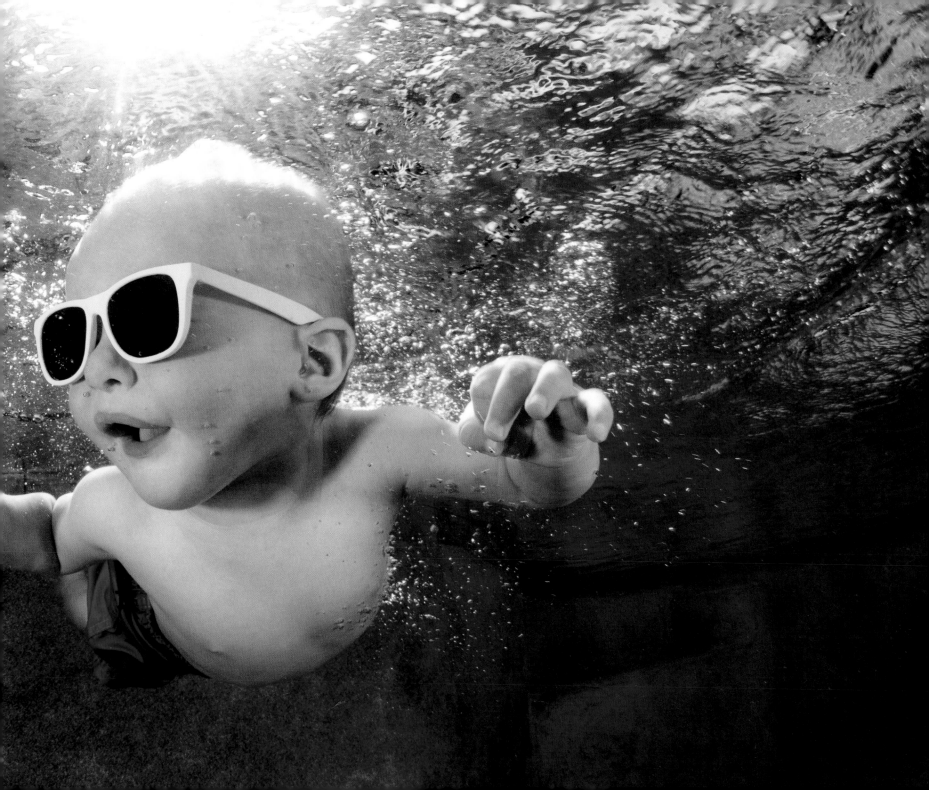

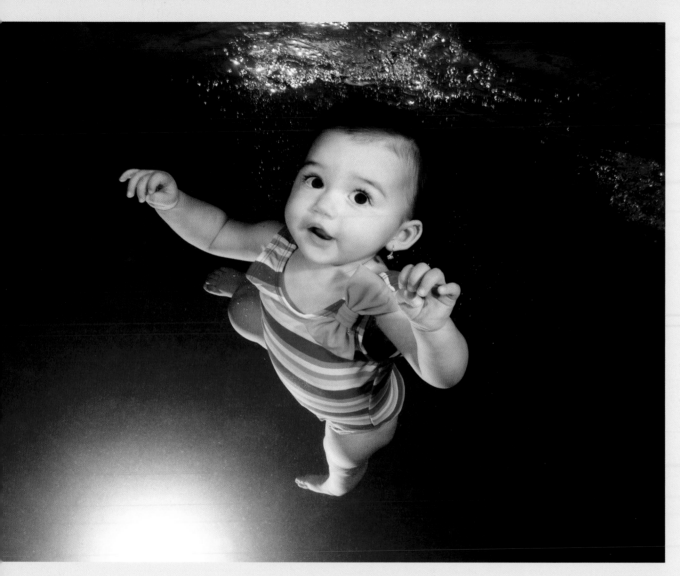

Nicole, 12 months

Michael R., 4.5 months

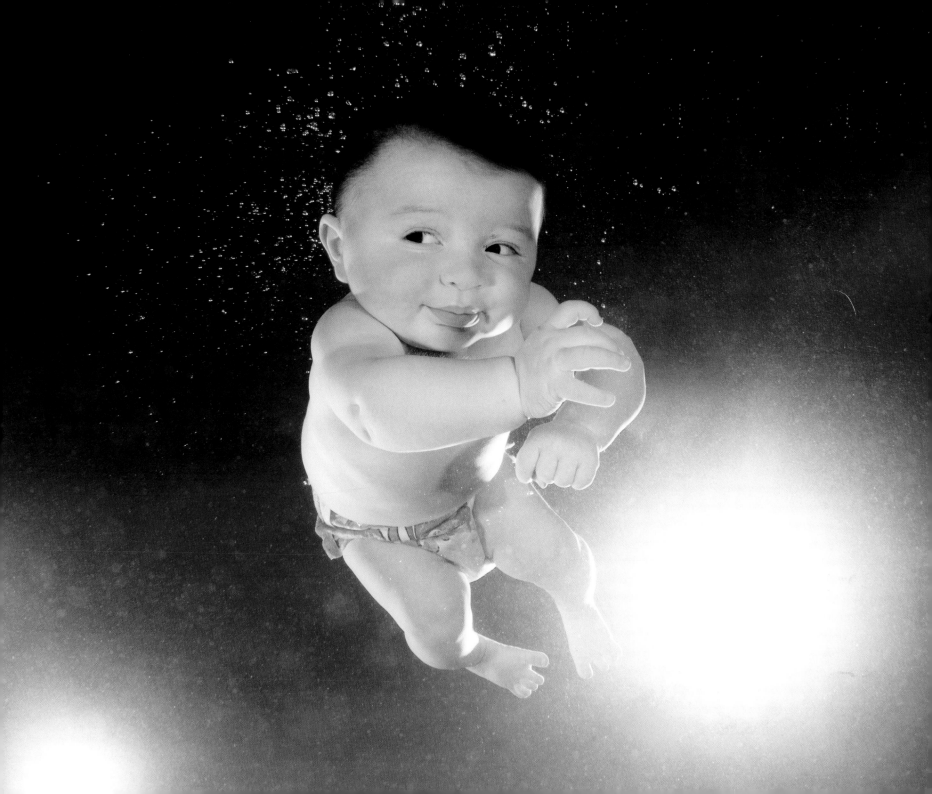

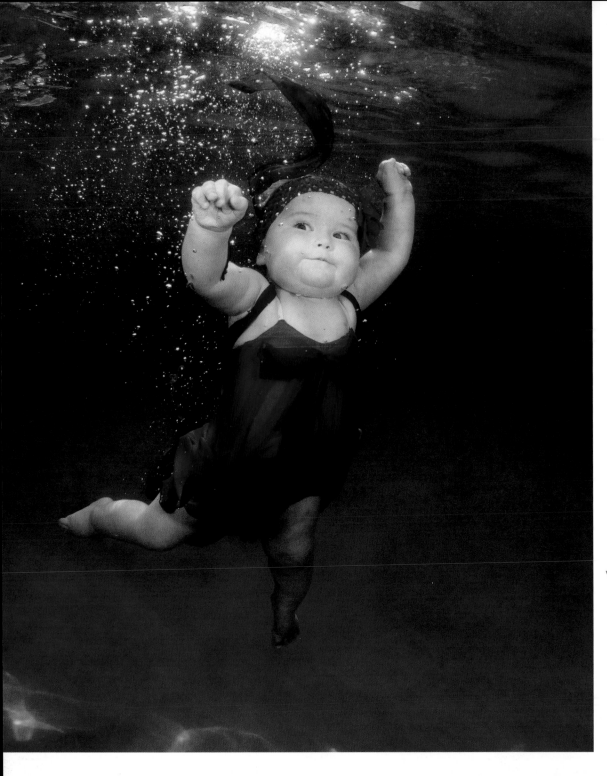

Valentina, 9 months

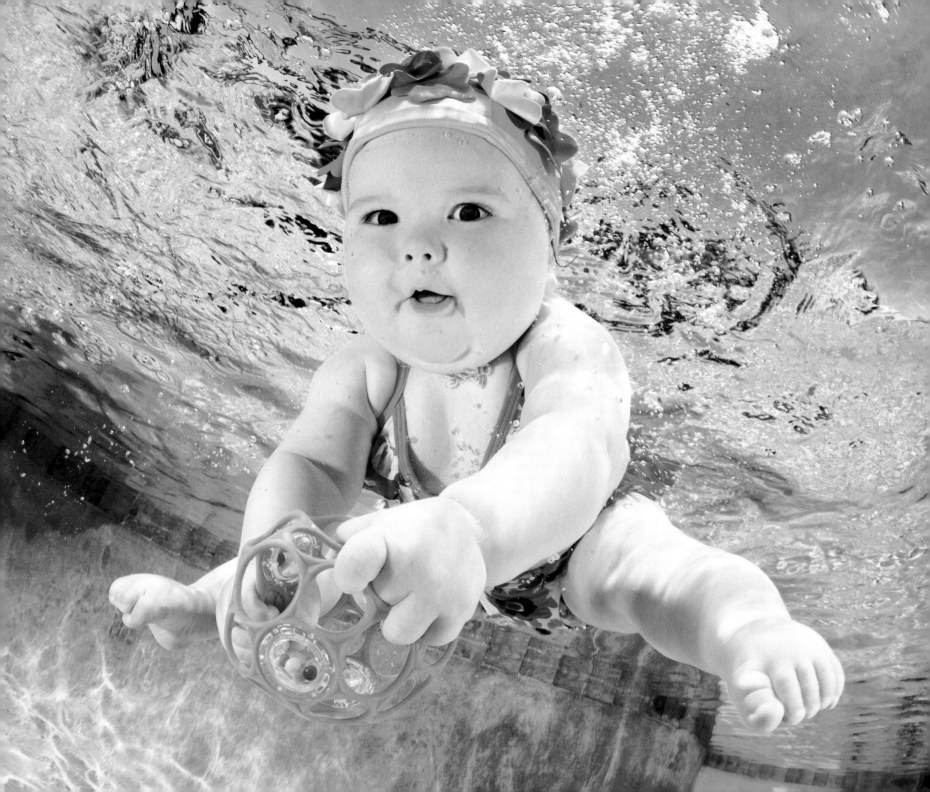

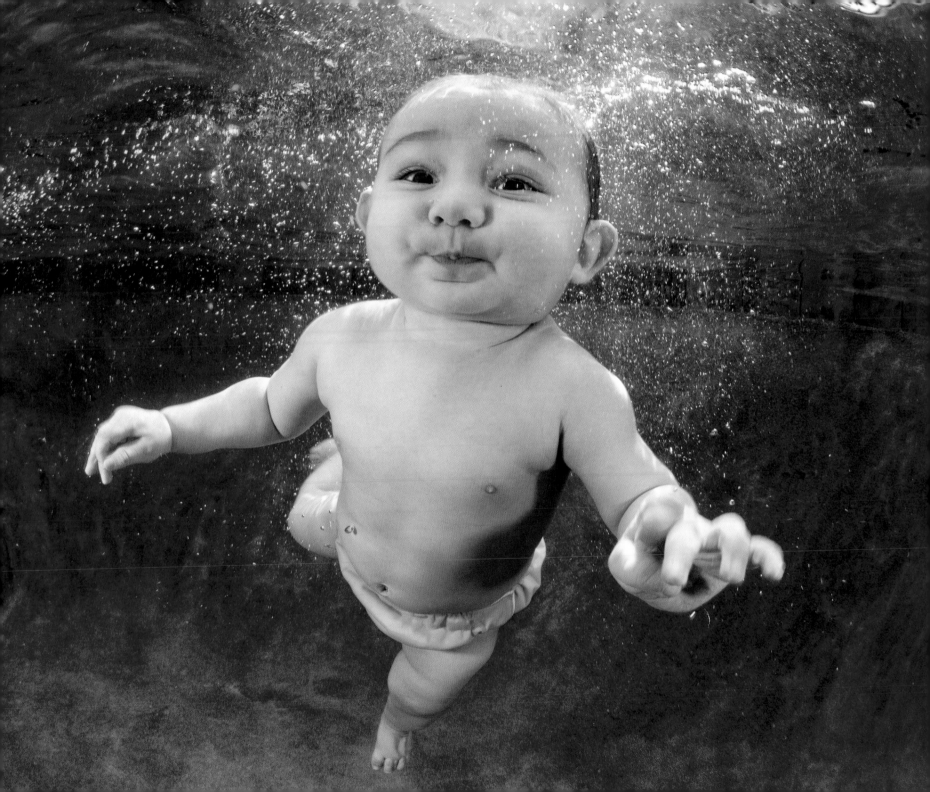

Warren L., 9 months

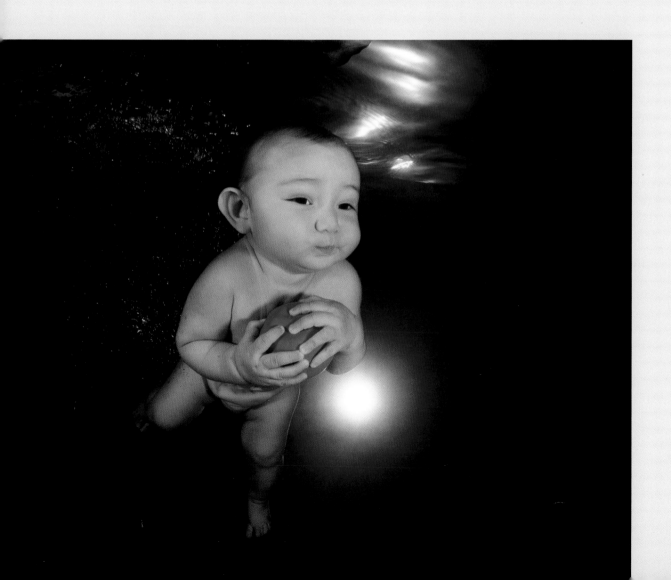

Natalie, 7 months

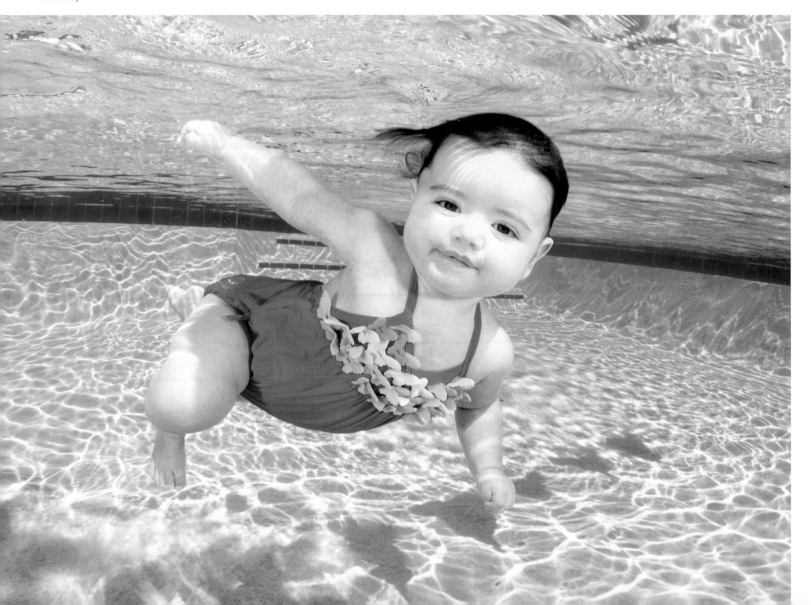

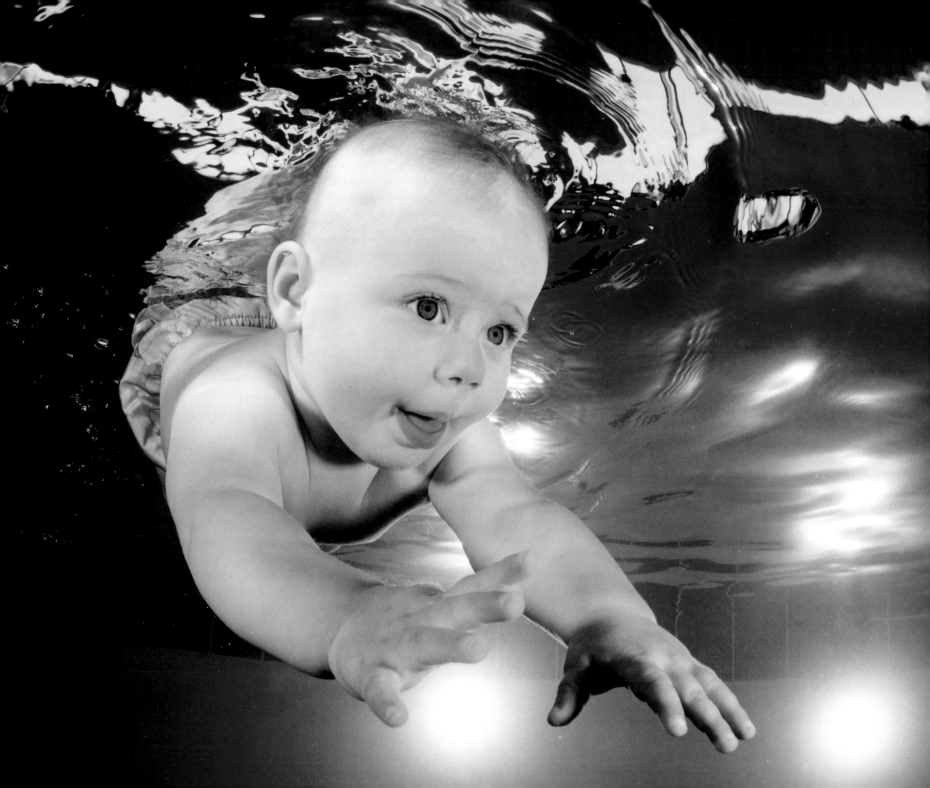

Sloane, 13 months

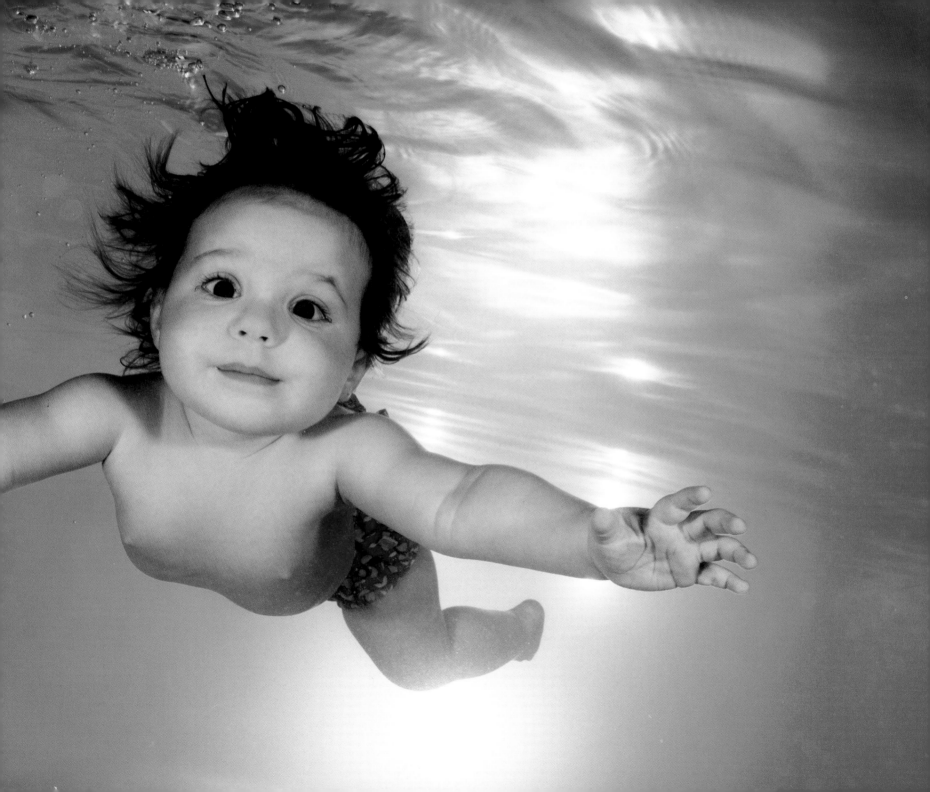

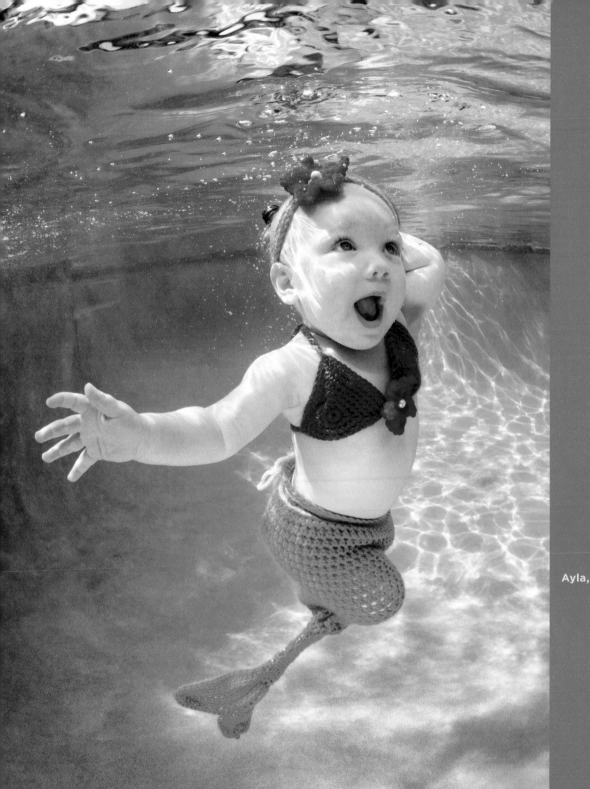

Ayla, 7 months

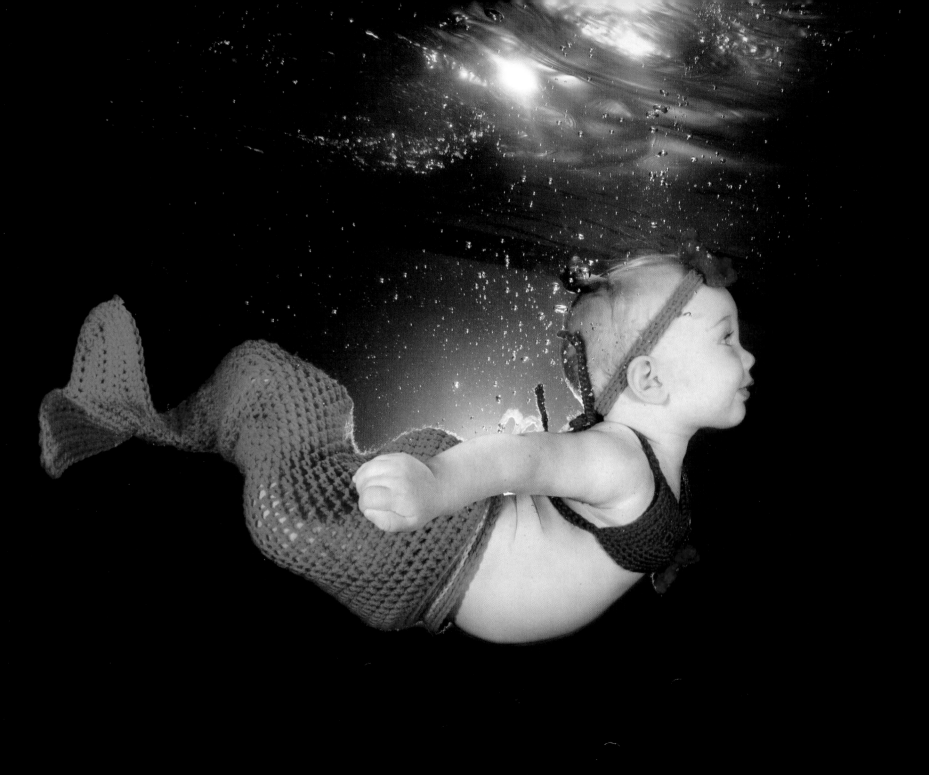

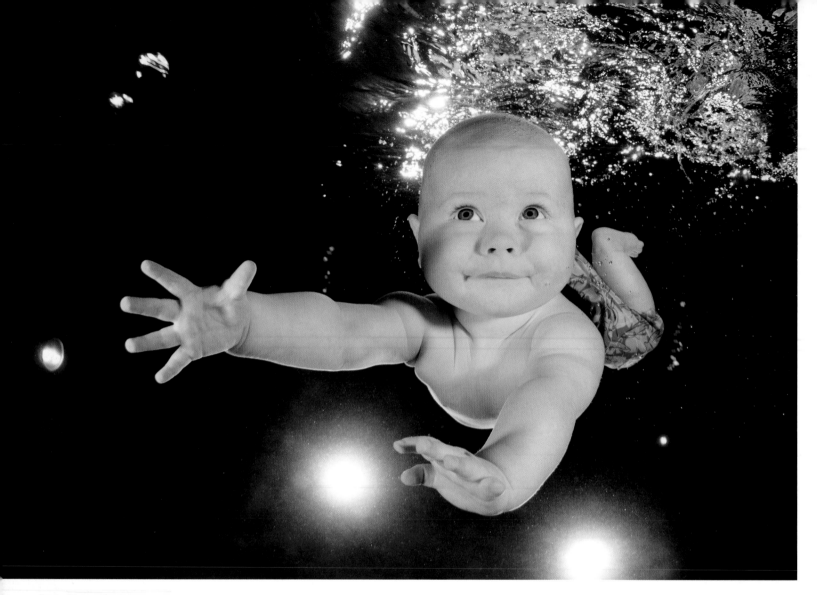

Ben, 5 months

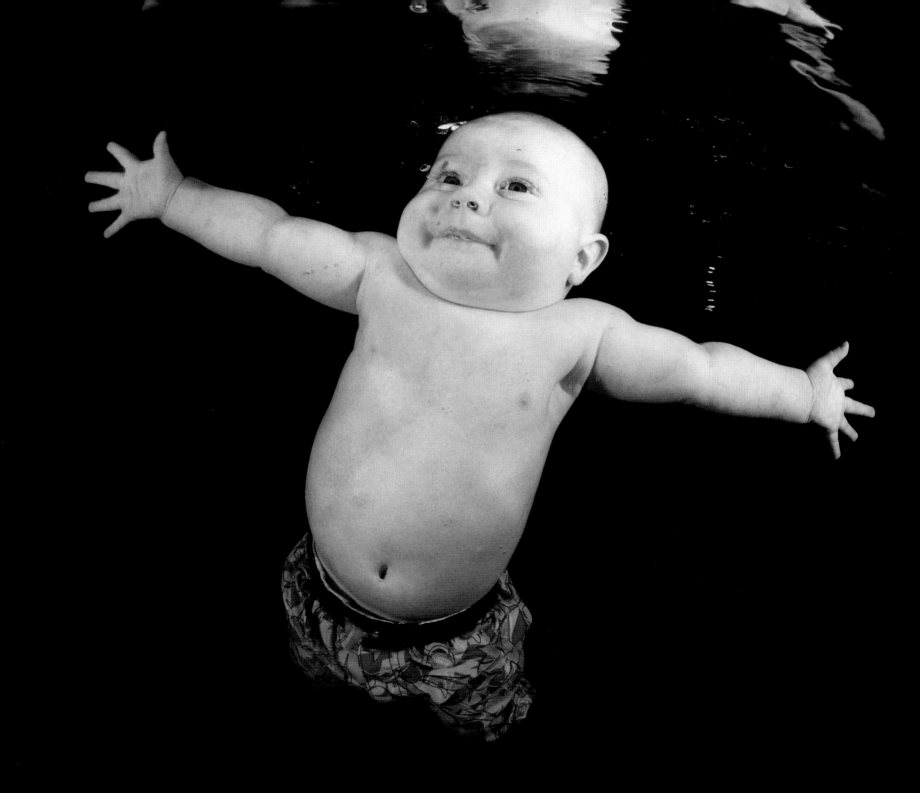

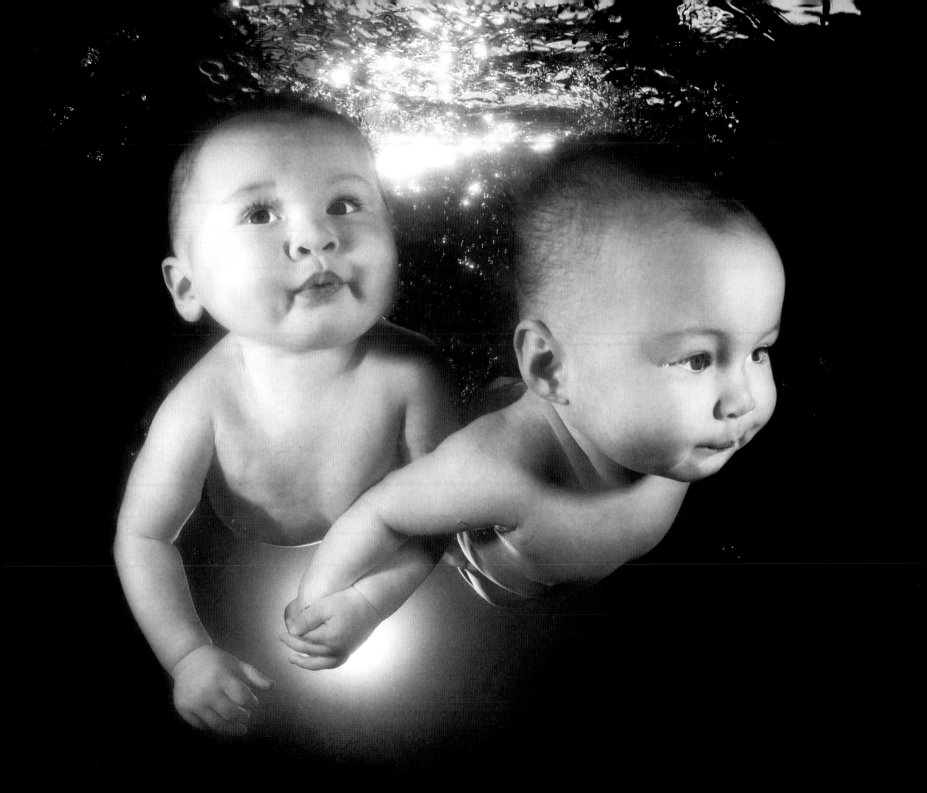

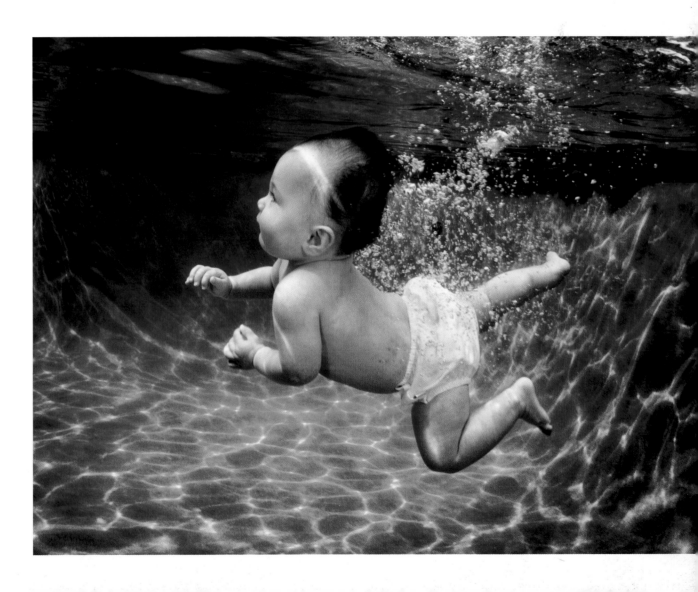

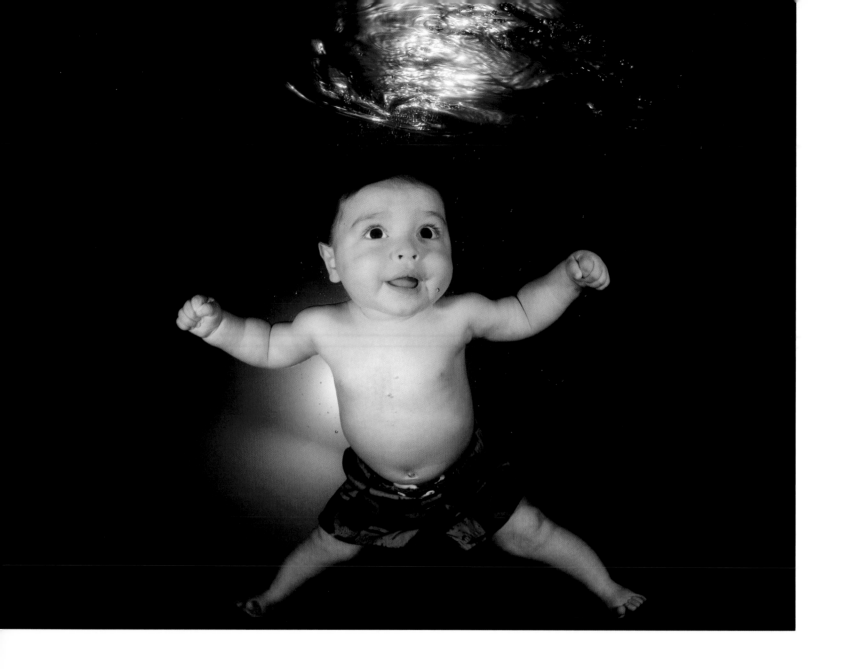

Henry A., 8 months

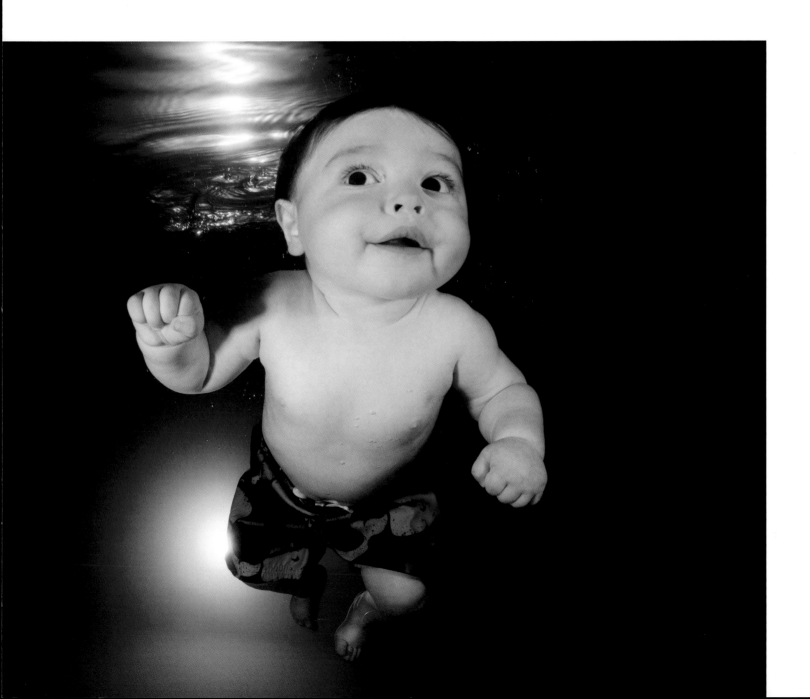

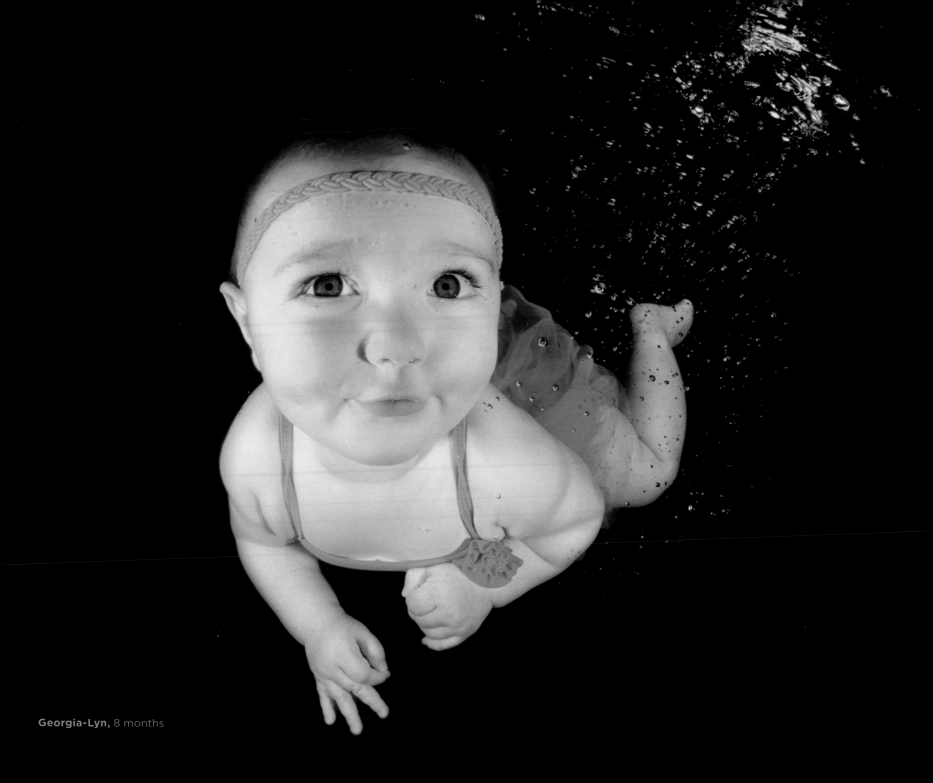

Georgia-Lyn, 8 months

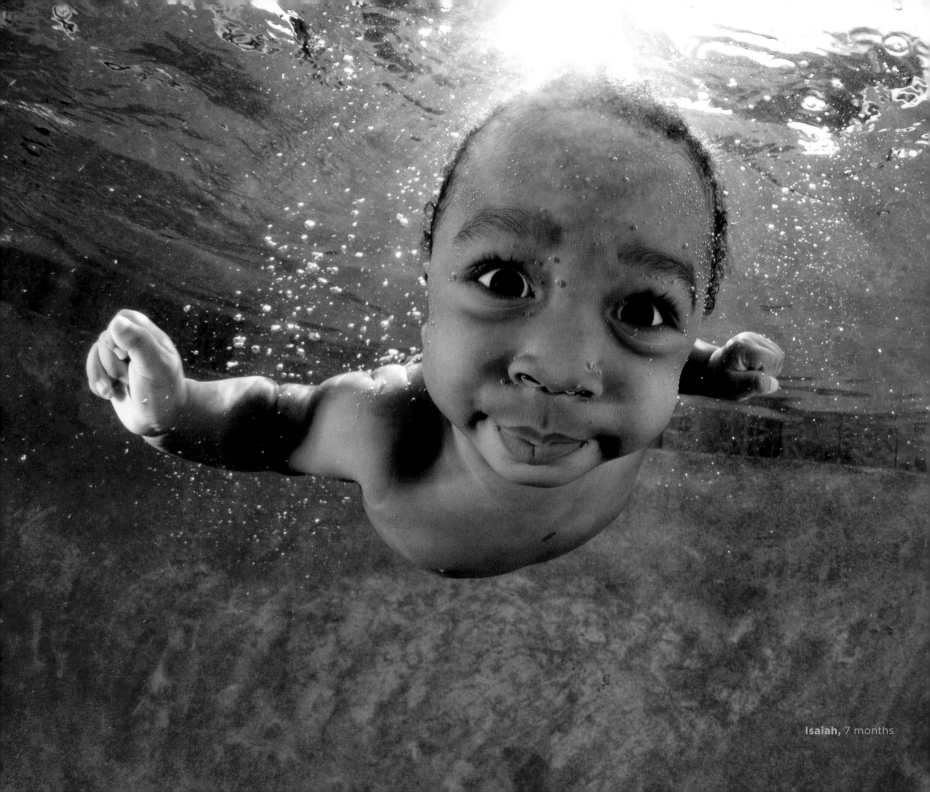

Isaiah, 7 months

Vossie, 6 months

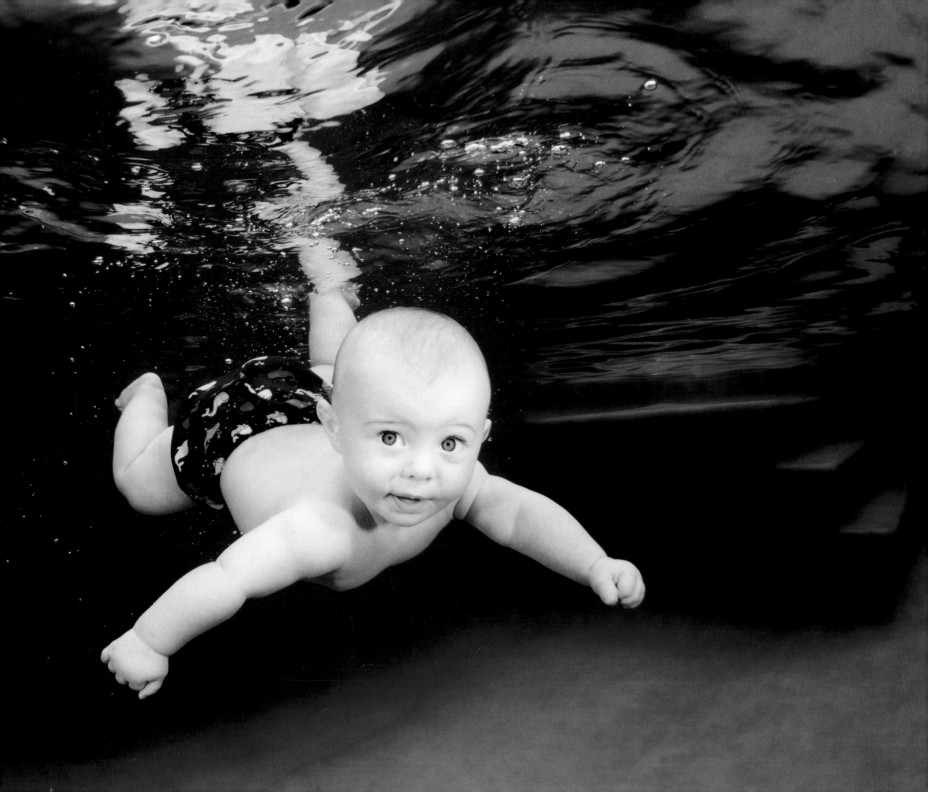

Teddy, 9 months

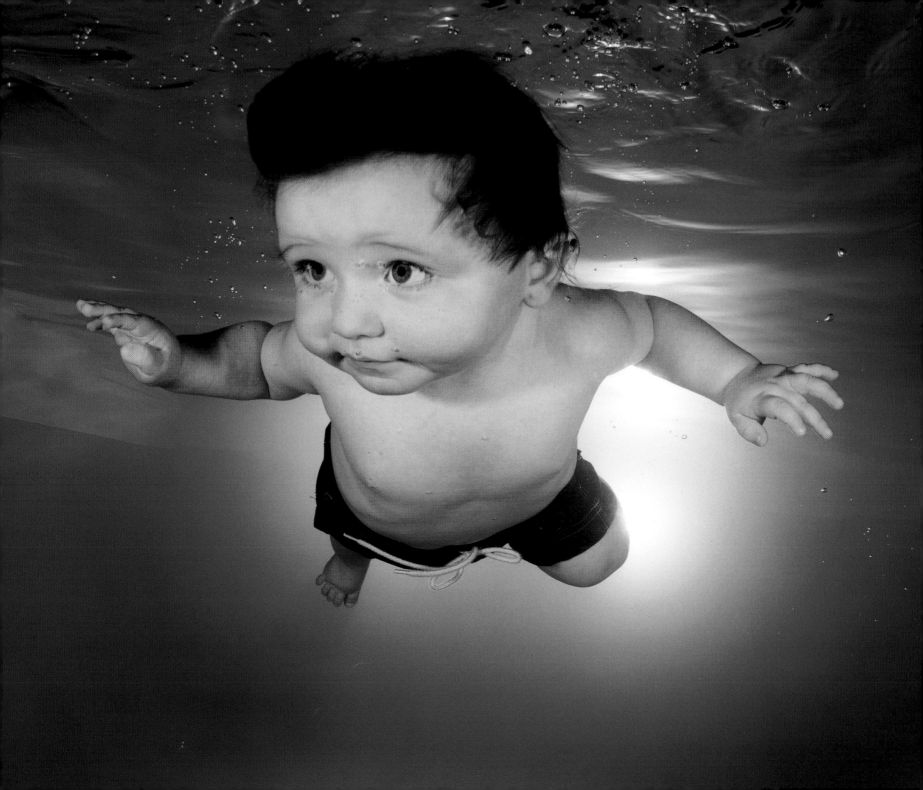

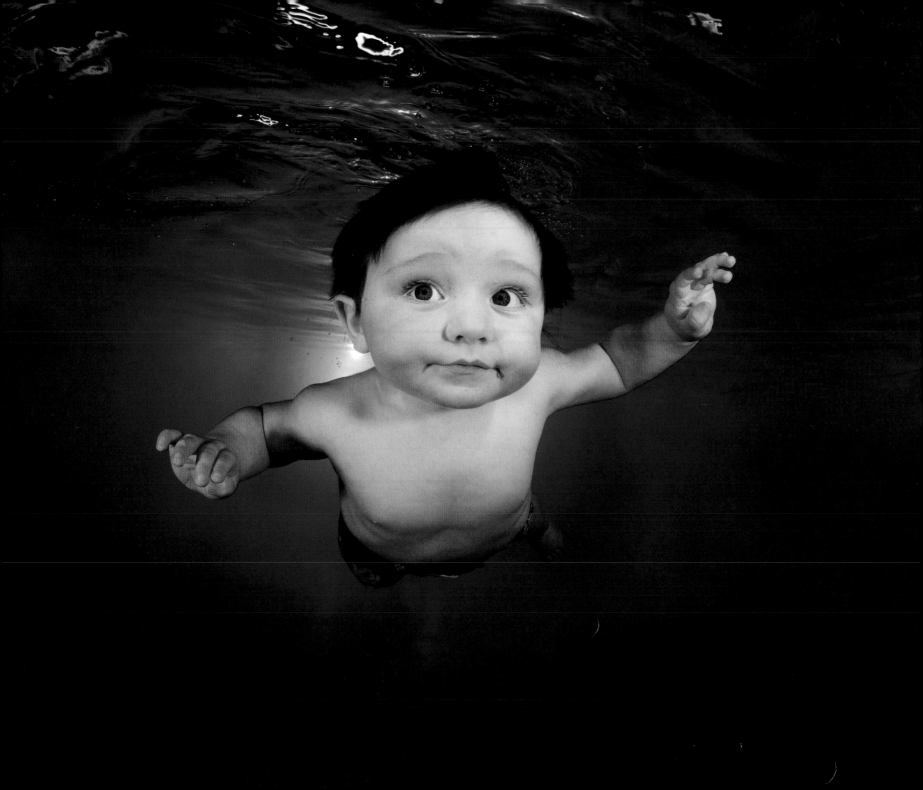

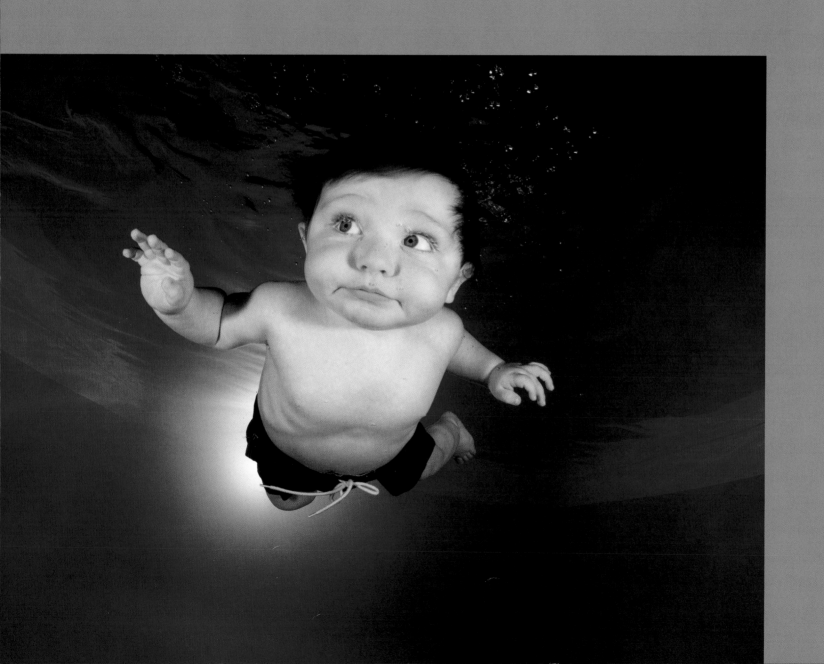

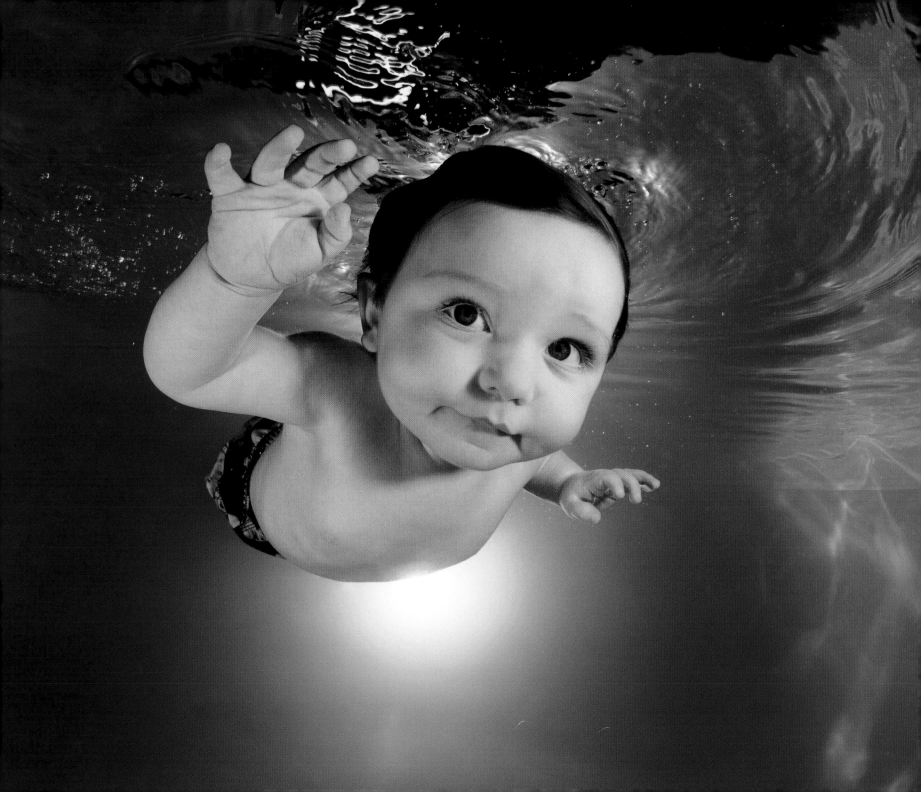

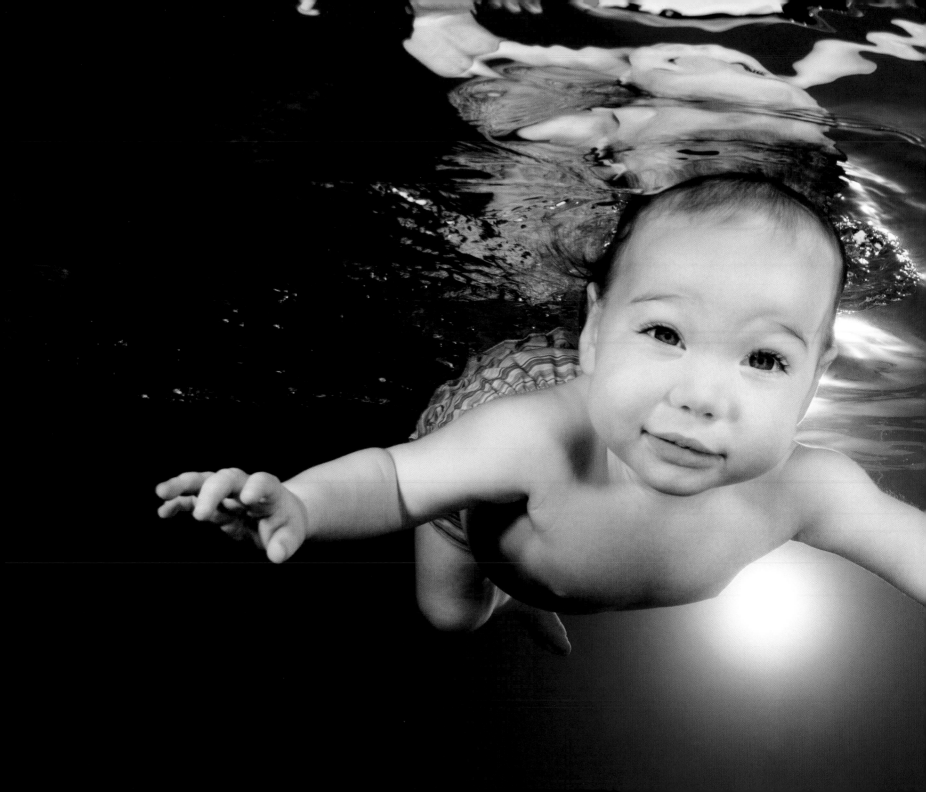

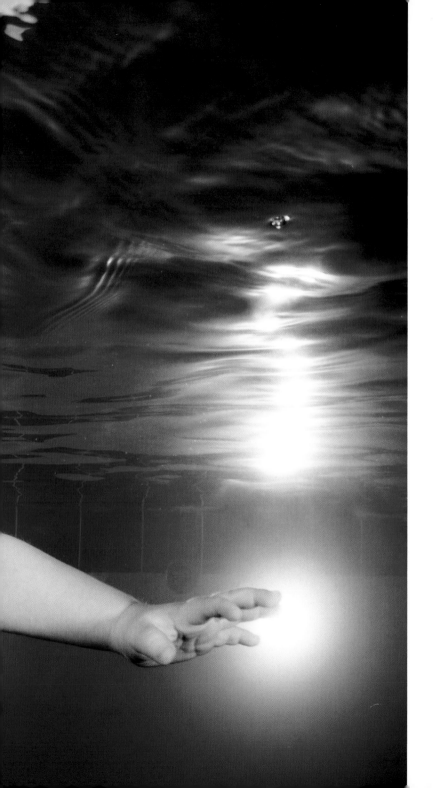

Grace, 17 months

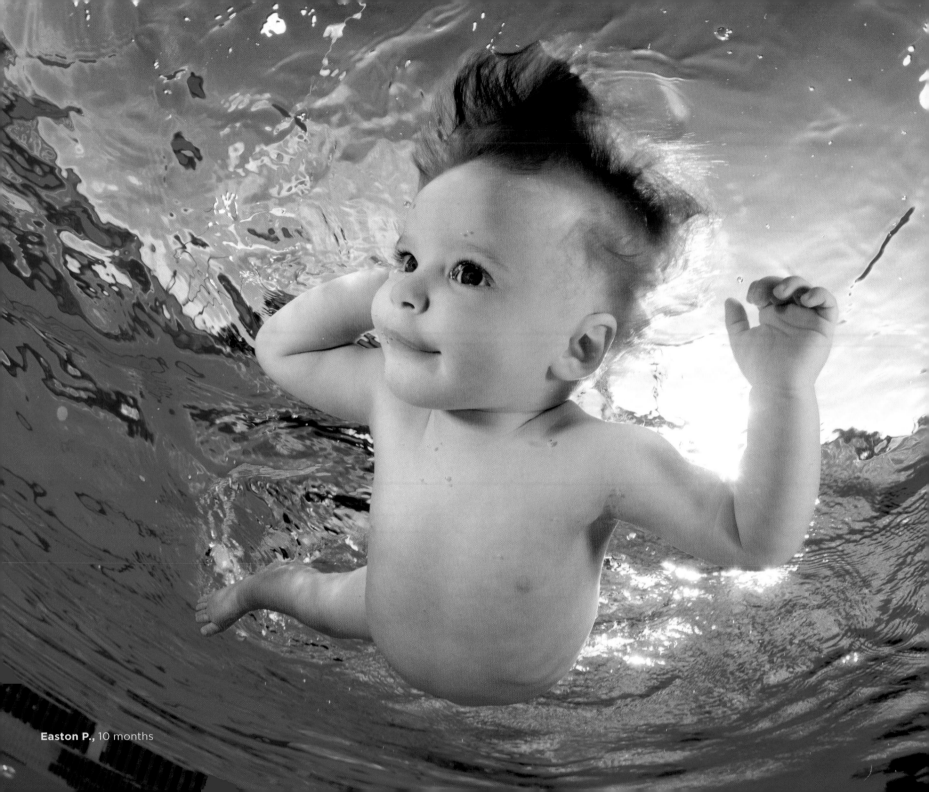

Easton P., 10 months

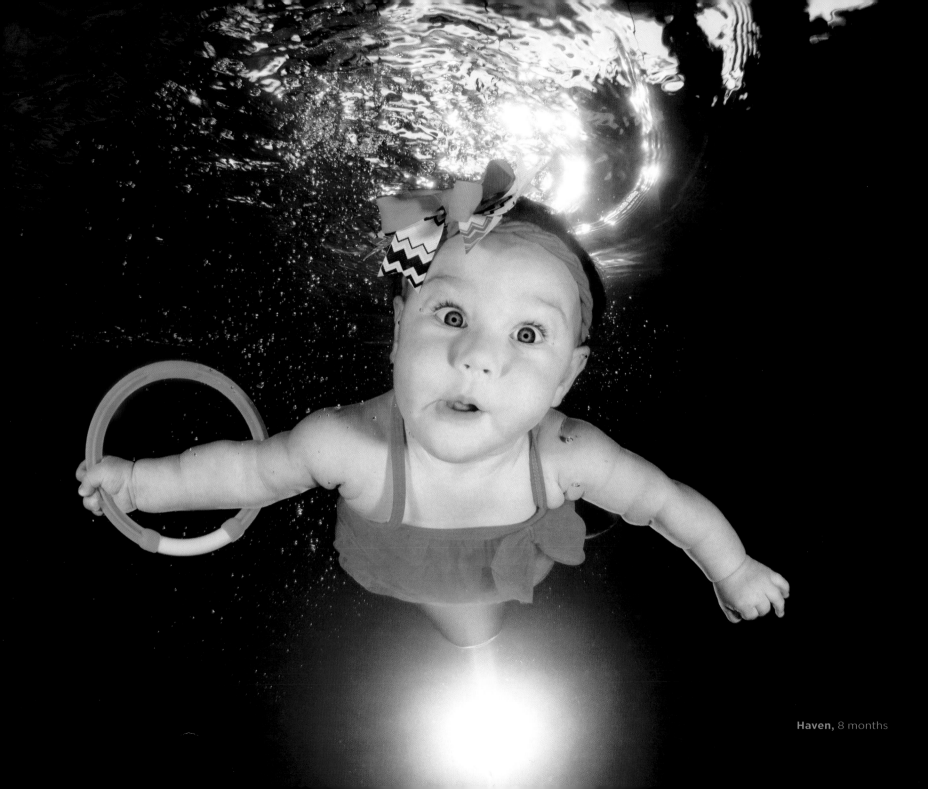

Haven, 8 months

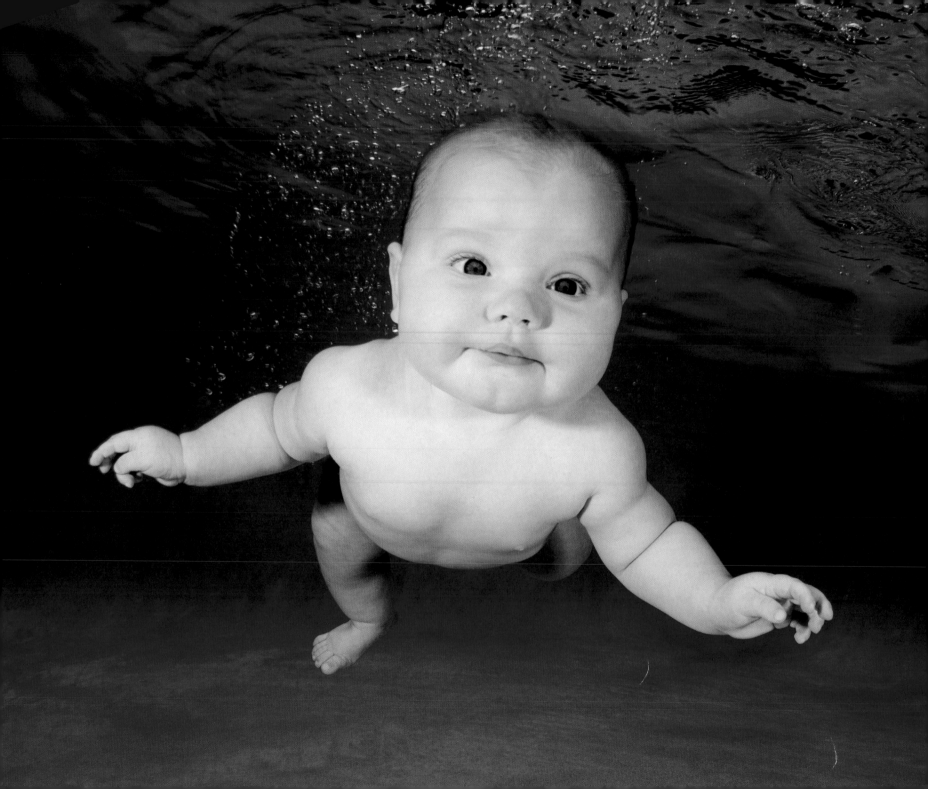

Claire, 7 months

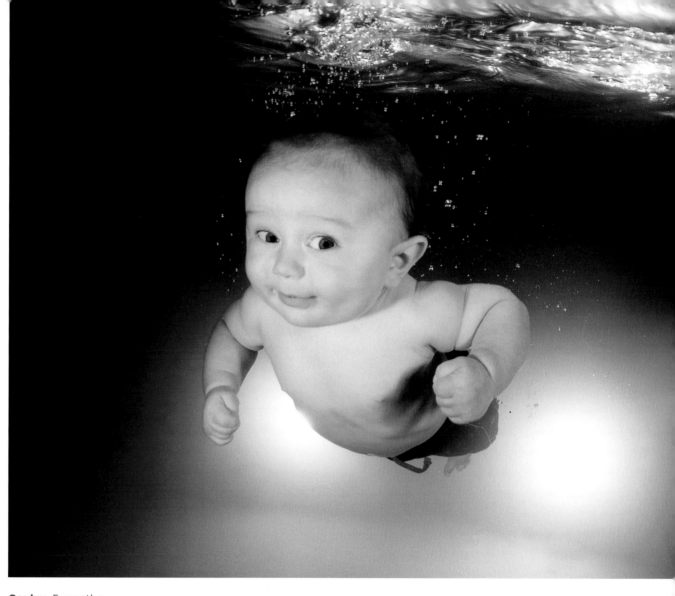

Conley, 5 months

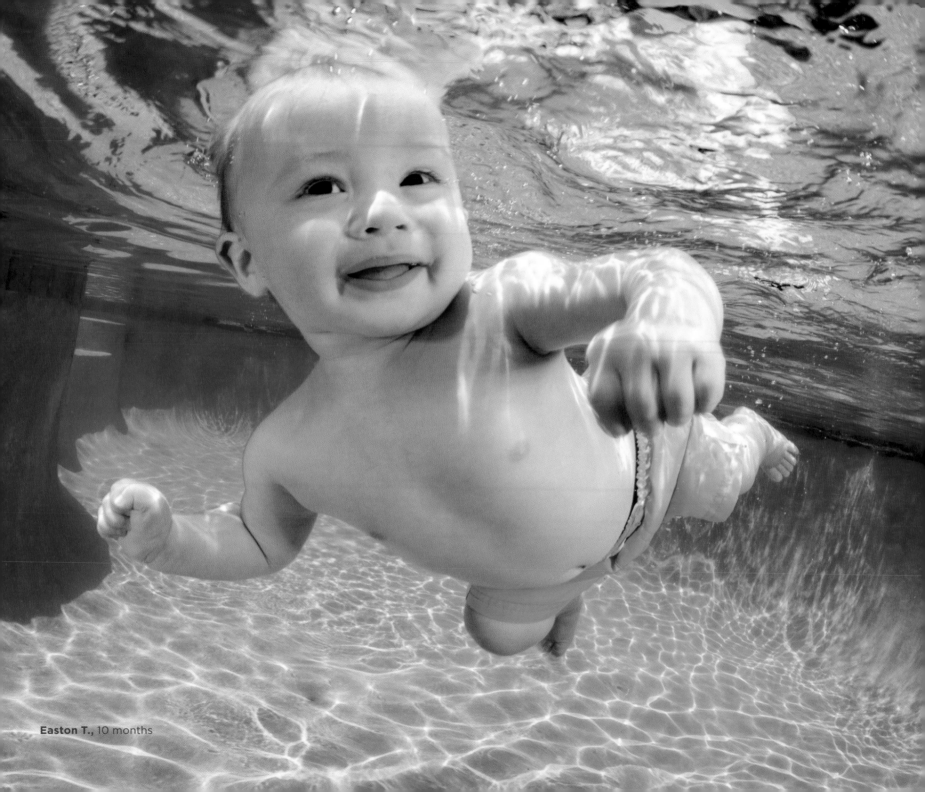

Easton T., 10 months

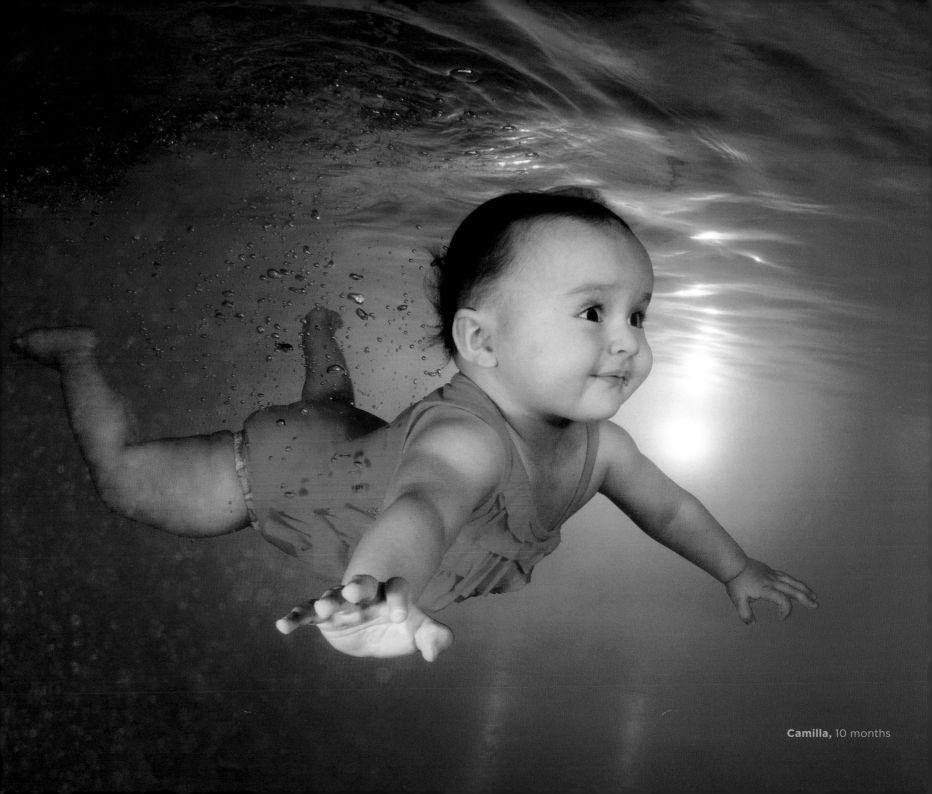

Camilla, 10 months

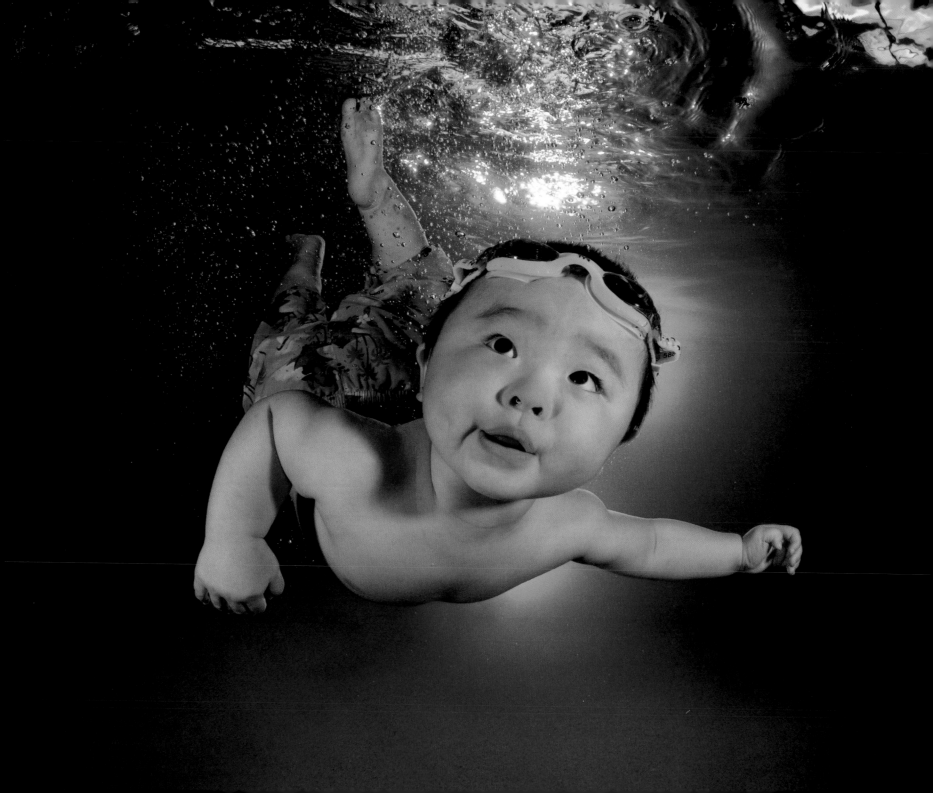

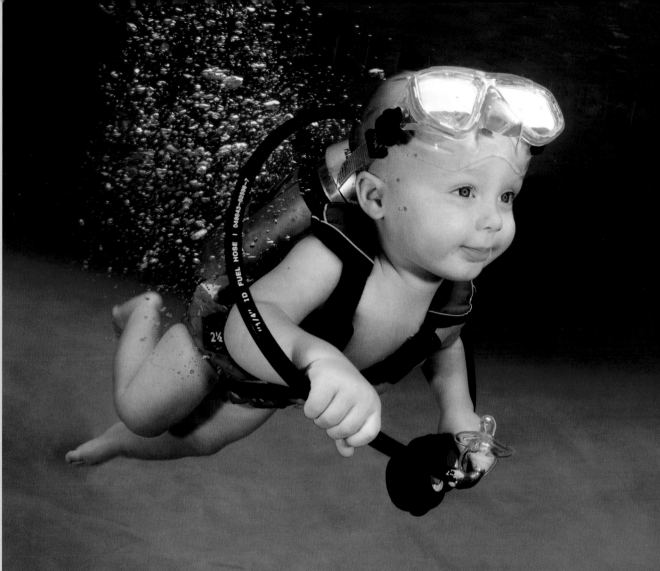

Colton, 11 months

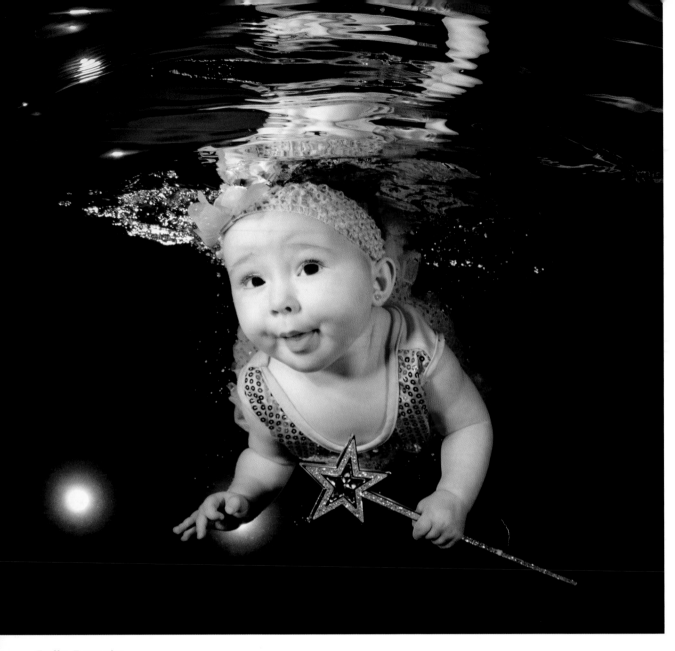

Emily, 7 months

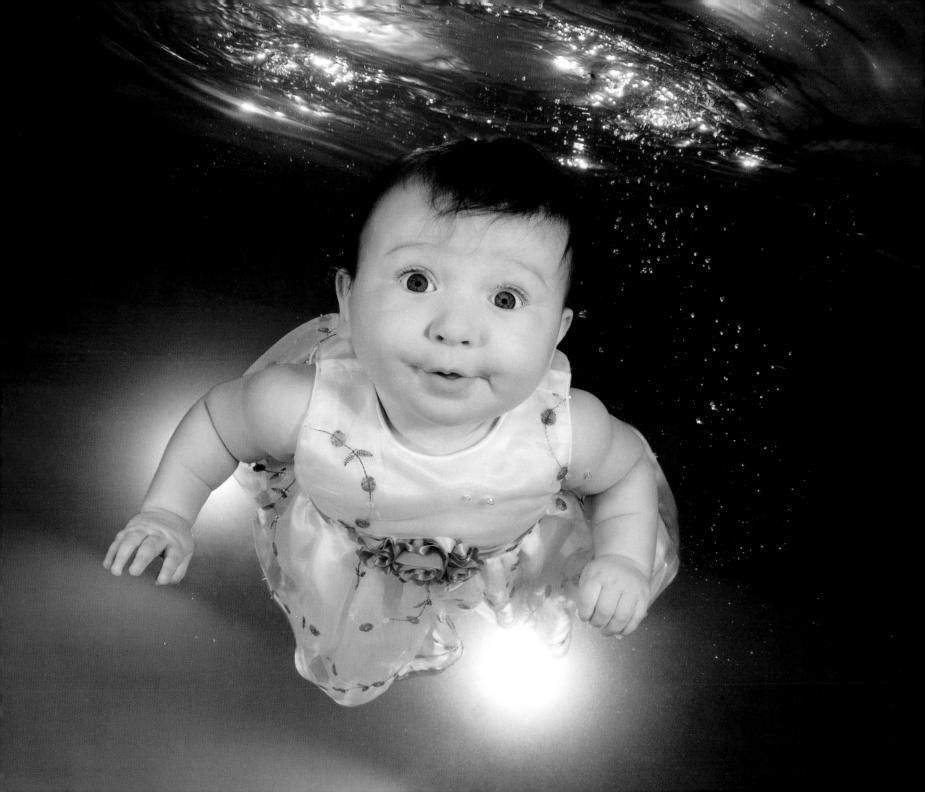

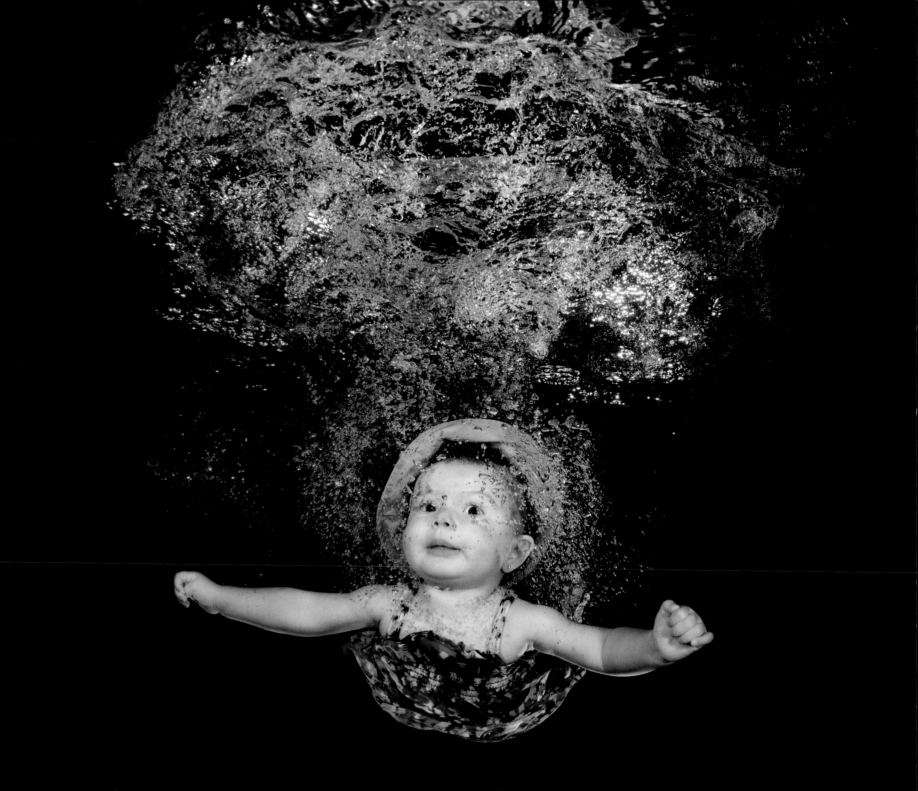

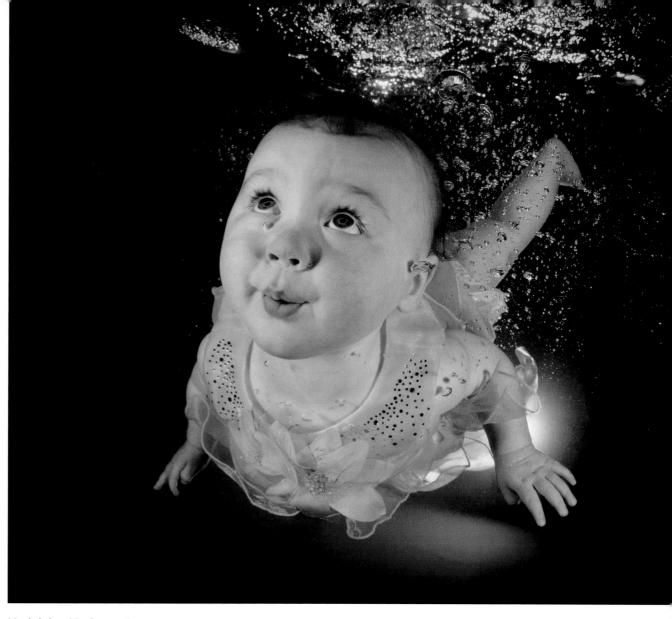

Madeleine M., 9 months

Hunter, 12 months

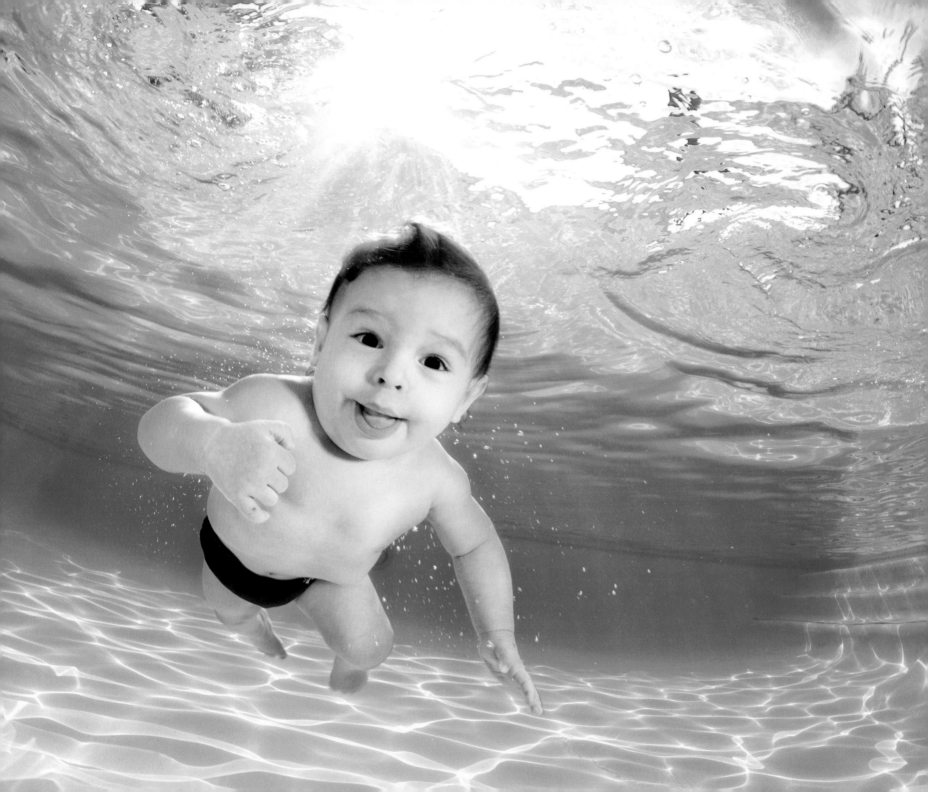

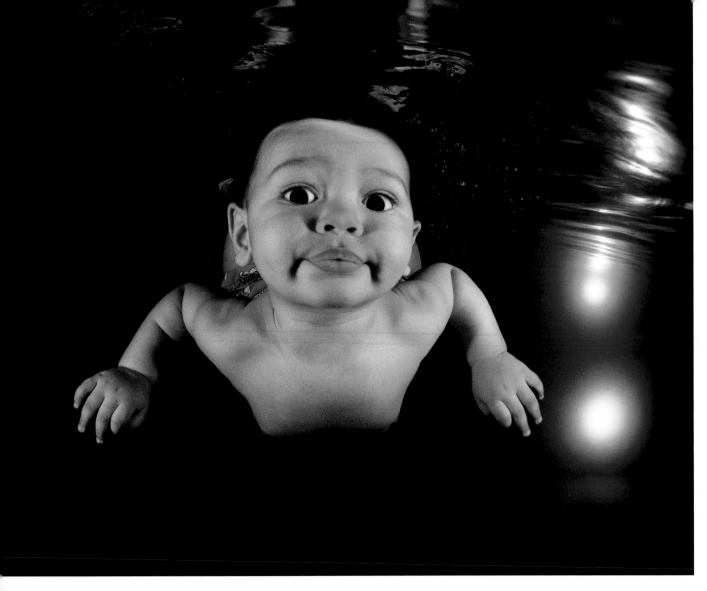

Hendrix, 6 months

Khyleigh, 9 months

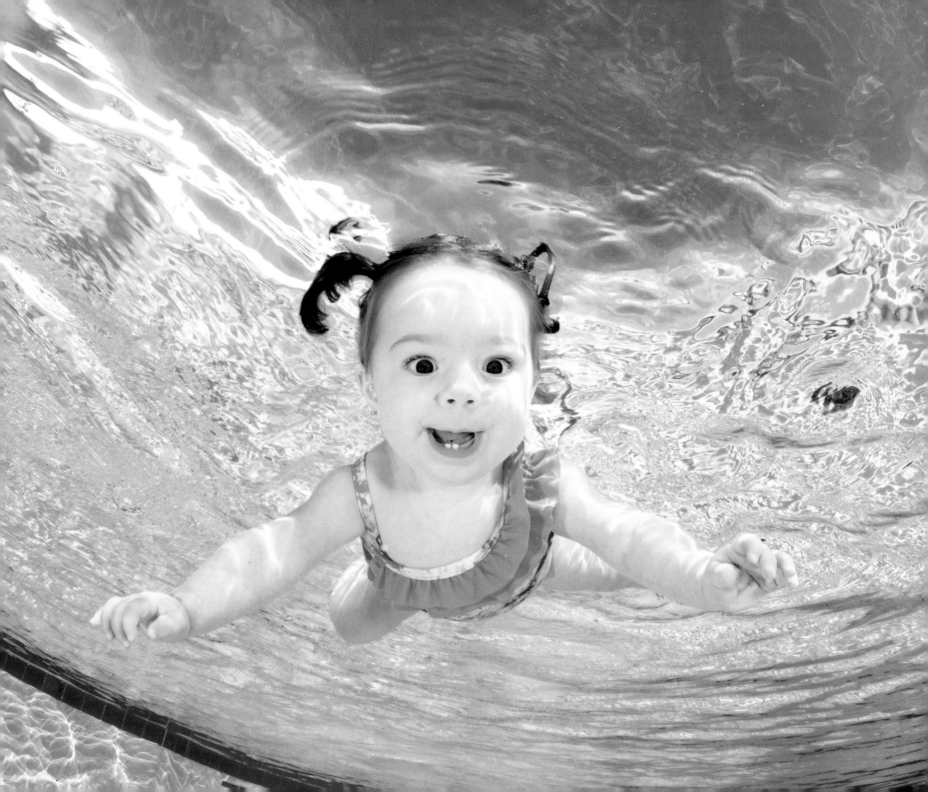

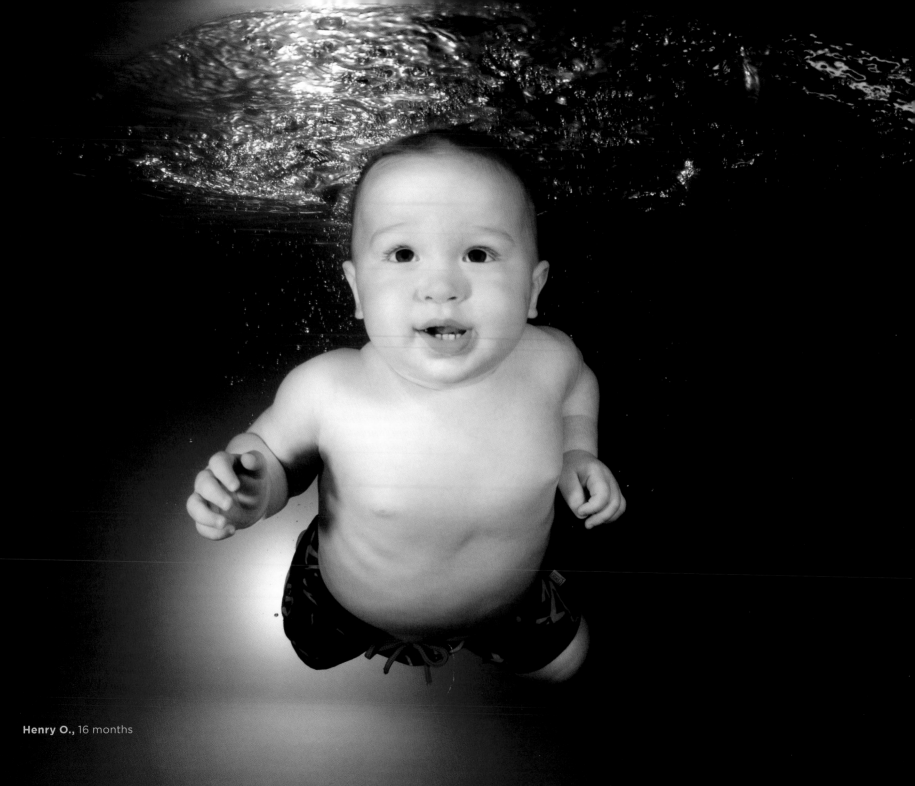

Henry O., 16 months

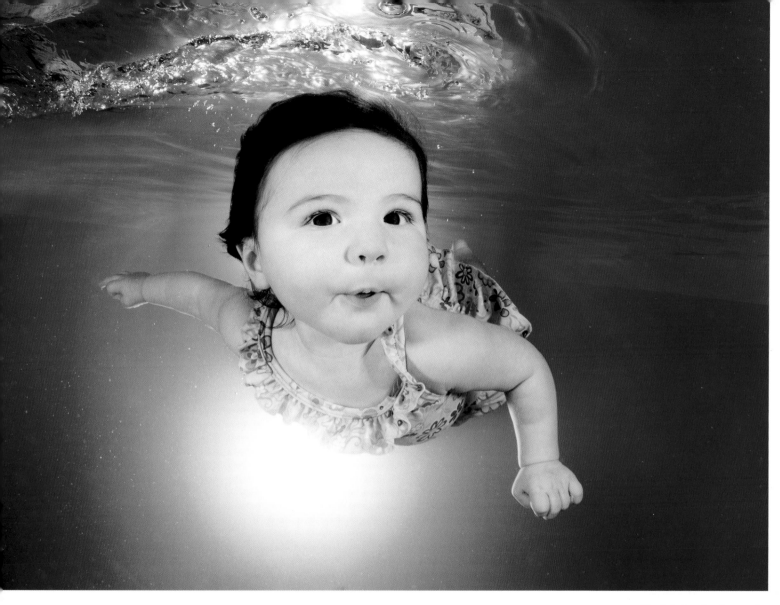

Madeleine S., 8 months

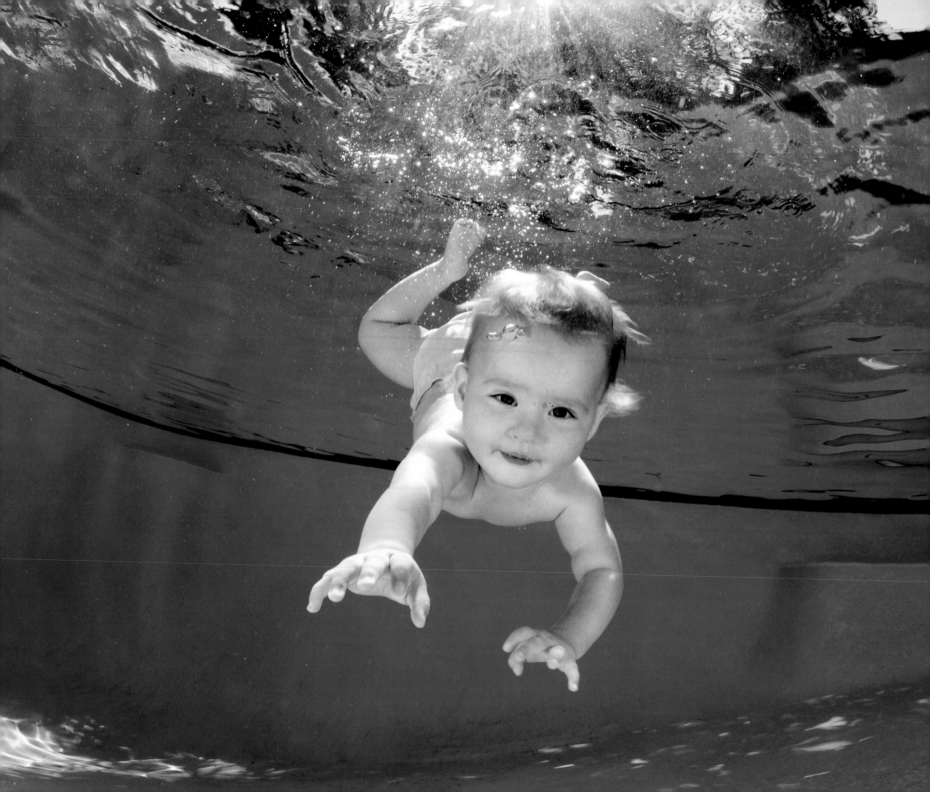

Veronica, 12 months

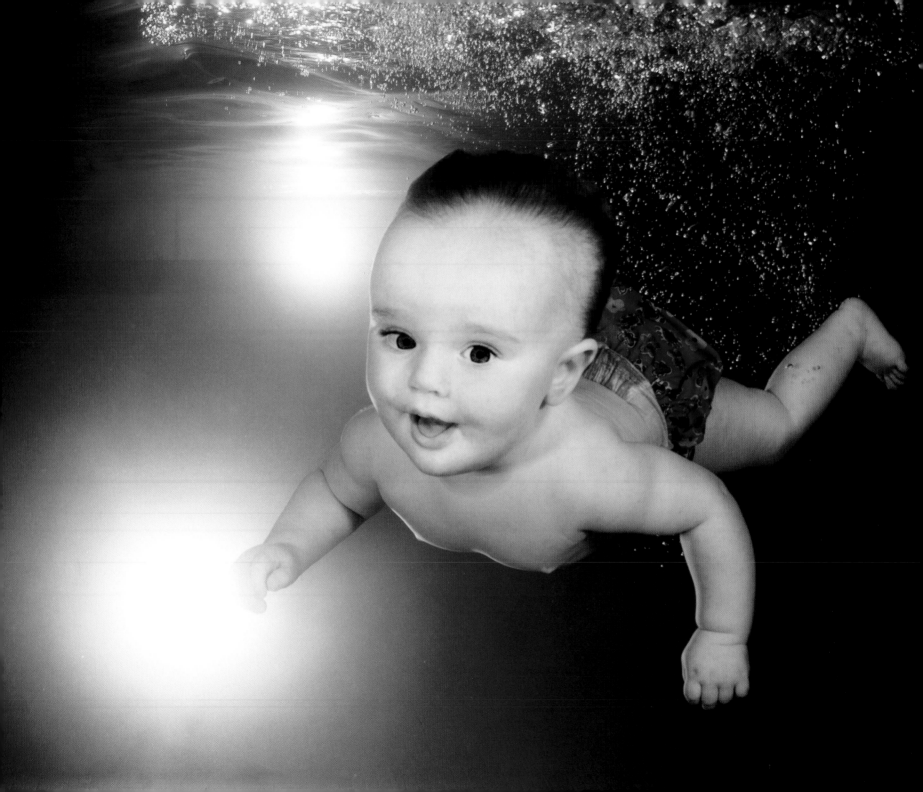

Jenner, 12 months

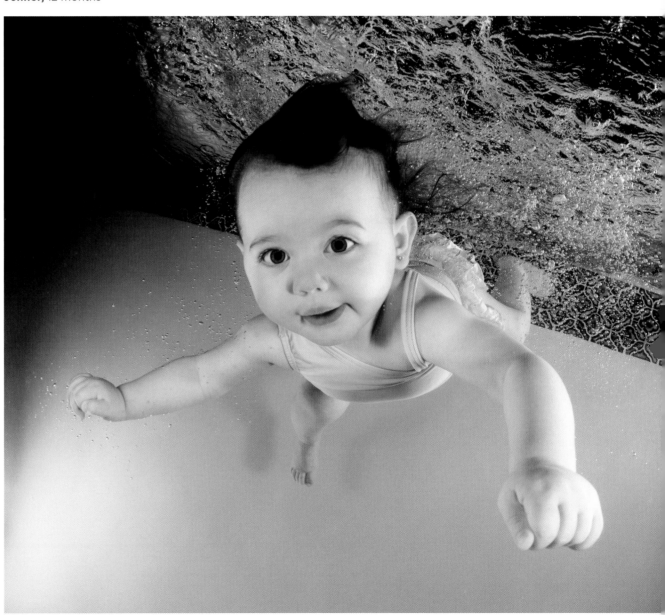

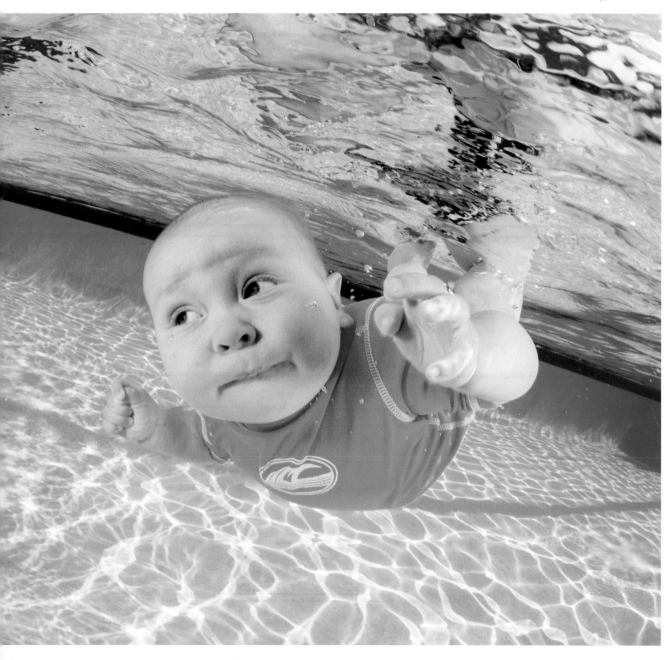

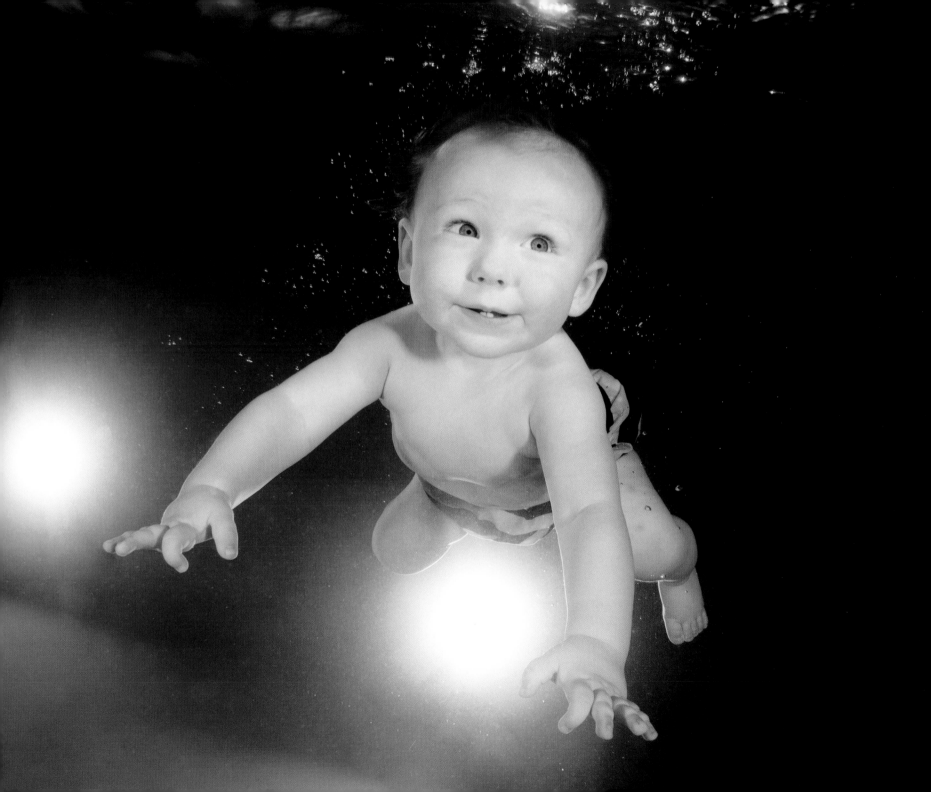

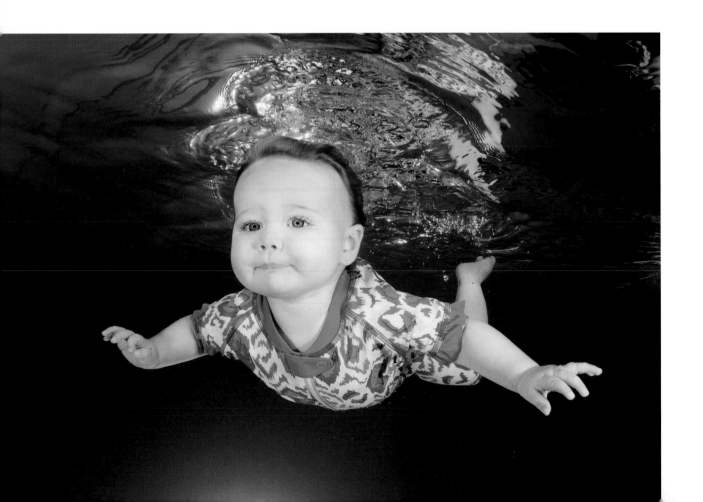

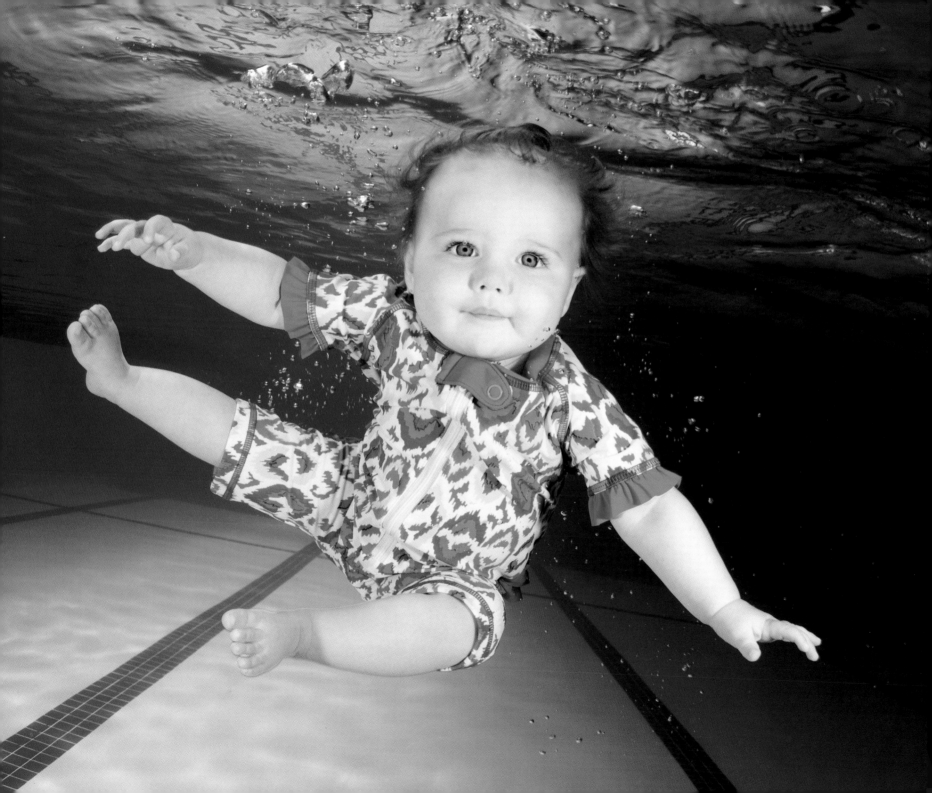

Keira, 11 months

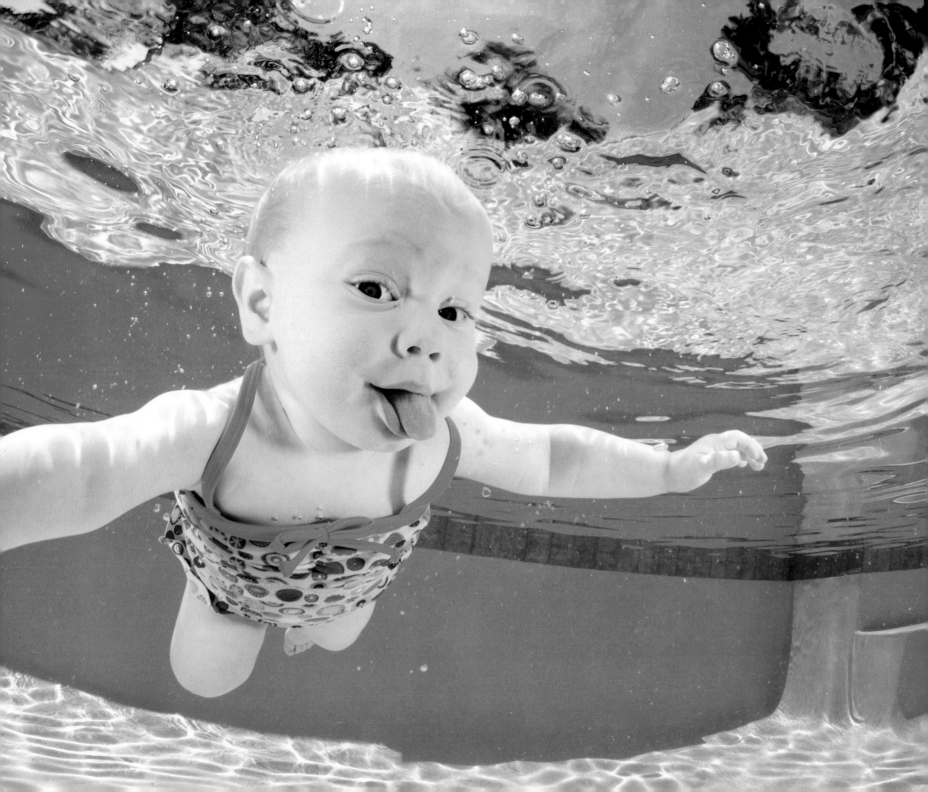

The Babies on Land

Adeline

Aizlynn

Alexandra

Amelia Mae

Ariana

Ayla

Bailey

Basil Marie

Ben

Brooklyn

Cameron

Camilla

CeCe

Charles

Claire

Colton

Conley

Easton P.

Easton T.

Emerson

Emily

Emma

Evan

Gabriella

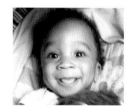

Georgia-Lyn

Grace

Harper H.

Harper M.

Haven

Hendrix

Henry A.

Henry O.

Hunter

Isabel B.

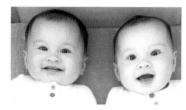

Isabel and Sabrina S.

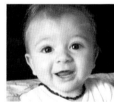

Isaiah

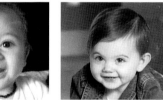

Ivan

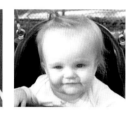

Jenner

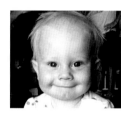

Kali

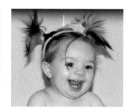

Keira

Khyleigh

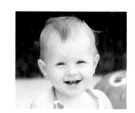

Kyndall

Landry

Madeleine M.

Madeleine S.

Mia

Michael G.

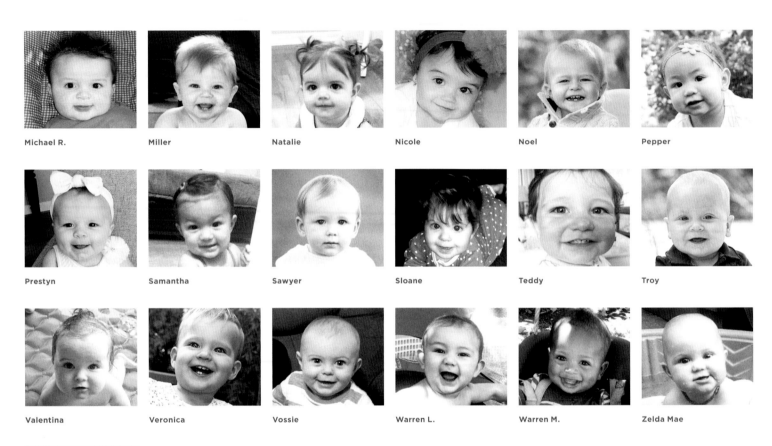

Michael R.

Miller

Natalie

Nicole

Noel

Pepper

Prestyn

Samantha

Sawyer

Sloane

Teddy

Troy

Valentina

Veronica

Vossie

Warren L.

Warren M.

Zelda Mae

Zoe

Acknowledgments

Thank you to each and every baby and parent that participated in the creation of this book!

Thanks to my entire family for their love and support—and for ensuring I was a happy and healthy baby who developed a love for the water!

Thank you to my literary agent, Michelle Tessler, and my editor, John Parsley, for believing in my photographs and providing the opportunity to share my work and messages with millions of people around the world.

A big shout-out to Ikelite Underwater Systems and John Brigham for providing innovative underwater camera equipment to assist in achieving this collection of photographs.

Jan Emler, Vilma Vasquez, Jessie McFadin, and Kendra Walker—you are wonderful human beings and I am grateful for the opportunity to collaborate with you all!

Nirvana and photographer Kirk Weddle for creating the innovative album cover in September 1991 and introducing swimming babies to pop culture!

Scott Stulberg and Holly Kehrt—thanks for teaching me to never grow old and always follow my dreams!

Marc Pearlman for outstanding behind-the-scenes videography!

Chapman University—thank you for inspiring and enabling students to pursue their passions!

Thanks also to:
C. J. Reynolds
Rosanna and Jerry Blais
Steve Ratts
Gary Tooth of Empire Design Studio
Joy McGinty and Maureen McGinty
Matt Driscoll
Whitney Baumgartner
Harvey Barnett, PhD
Karen Faust
Miss Glori
Lisa King
Jonathan Alegria
Kathleen McMordie

I would like to extend my sincere appreciation to the following infant swimming schools and their wonderful and compassionate staff members:

ARIZONA
Saguaro Aquatics
Tucson, AZ
saguaroaquatics.com

CALIFORNIA
Southbay Aquatics
Torrance, CA
southbayaquatics.com

Lenny Krayzelburg Swim Academy
Los Angeles, CA
lennykswim.com

FLORIDA
Harvey Barnett, PhD
Founder, Infant Swimming Resource
infantswim.com

Miss Glori, ISR Instructor
Orlando, FL
babyaquatics.com

Safe Start Survival Swim Program
Central Florida YMCA
Orlando, FL
ymcacentralflorida.com

Lisa King, RN
Sr. Master Instructor,
Infant Swimming Resource
infantswim.com

SouthWest Aquatics
Home of PediaSwim and
the Gift of Swimming
Winter Garden, FL
southwestaquatics.com
giftofswimming.org

ILLINOIS
Goldfish Swim School
Chicago, IL
goldfishswimschool.com

Decatur Family YMCA
Decatur, IL
decaturymca.org

YMCA of Springfield, IL
Springfield, IL
springfieldymca.org

LOUISIANA
Love Swimming
New Orleans, LA
loveswimming.com

NEVADA
Las Vegas Swim Academy
Las Vegas, NV
lvswimacademy.com

NEW YORK
Asphalt Green
New York, NY
asphaltgreen.org

OREGON
Farber Swim School
Beaverton, OR
farberswimschool.com

TEXAS
Emler Swim School
Dallas and Austin, TX
emlerswimschool.com

Houston Swim Club
Houston, TX
houstonswimclub.com

Texas Swim Academy
Katy, TX
texasswimacademy.com

About Seth Casteel

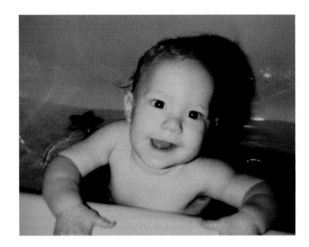

Seth Casteel is an award-winning photographer and the author of the bestsellers *Underwater Dogs* and *Underwater Puppies*. To take the photographs in *Underwater Babies,* Casteel partnered with infant swimming schools dedicated to helping babies build confidence and safety skills in the water, creating safe and fun environments for beginner swimmers. He lives in California.